American Reflections

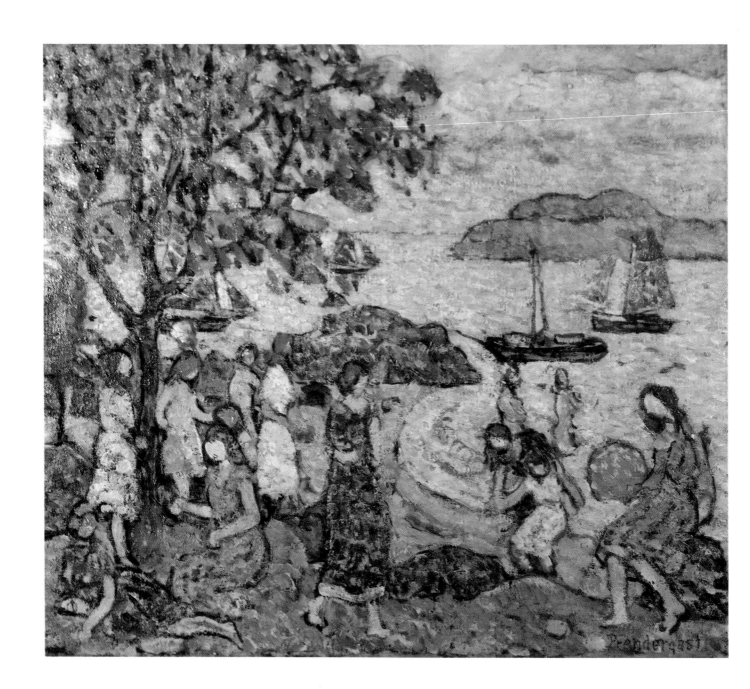

Catalogue by
Marjorie Harth Beebe
Naomi Sawelson-Gorse
Kay Koeninger
Mary M. Longtin
Melinda Lorenz
Arthur D. Stevens

Edited by
Kay Koeninger

American Reflections

Paintings 1830–1940

From the Collections of Pomona College and Scripps College, Claremont, California

American Reflections

DECEMBER 15, 1984–FEBRUARY 13, 1985
Tucson Museum of Art
Tucson, Arizona

MARCH 2–APRIL 14, 1985
Tyler Museum of Art
Tyler, Texas

MAY 5–JUNE 16, 1985
Monterey Peninsula
Museum of Art
Monterey, California

JULY 14–AUGUST 25, 1985
Charles H. MacNider
Museum
Mason City, Iowa

SEPTEMBER 15–OCTOBER 27,
1985
Colorado Springs Fine Arts
Center
Colorado Springs, Colorado

JANUARY 4–FEBURARY 15, 1986
Loch Haven Art Center
Orlando, Florida

MARCH 15–APRIL 26, 1986
Meadows Museum
Shreveport, Louisiana

MAY 17–JUNE 28, 1986
Arnot Art Museum
Elmira, New York

SEPTEMBER 6–OCTOBER 18,
1986
Anchorage Historical and
Fine Arts Museum
Anchorage, Alaska

NOVEMBER 14–DECEMBER 28,
1986
Beaumont Art Museum
Beaumont, Texas

1987
Galleries of The Claremont
Colleges
Claremont, California

EXHIBITION CIRCULATED
BY THE ART MUSEUM
ASSOCIATION OF AMERICA

Copyright 1984 Trustees of
Pomona College and Scripps
College
SAN 158-0515
ISBN 0-915478-52-8
Edited by Christine Kopitzke
Designed by Lilli Cristin,
Glendale, CA
Typeset in Aldus by
R S Typographics,
North Hollywood, CA
Lithographed on Quintessence
Text and Kromekote Cover by
Typecraft, Pasadena, CA

Funded in part by a grant from
The National Endowment for
the Arts, Washington, D.C., a
federal agency.

Cover: Jasper Francis Cropsey
Moonlit Lake, 1865 (detail)
oil on canvas
11 x 18 in. (28.0 x 46.0 cm.)
Frontispiece: Maurice Brazil
Prendergast
Crépuscule, c. 1920
oil on canvas
20¼ x 24¼ in. (51.4 x 61.6 cm.)

Contents

Foreword 11

Portraiture, Landscape and the Ideal 13

Major American Impressionists 49

Other American Impressionists and
Tonalism 75

The Ashcan School 107

New England Painters 127

The 1930s 137

Index 144

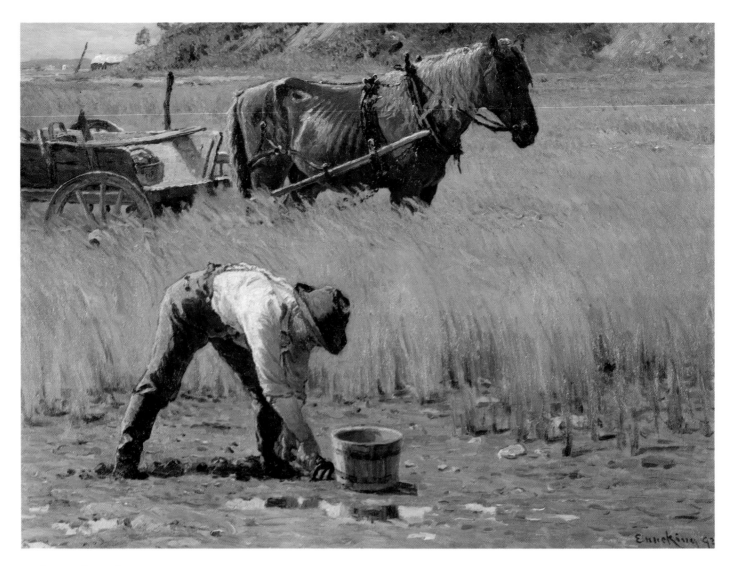

John Joseph Enneking
Duxbury Clam Digger, 1892
oil on canvas
22½ x 30½ in. (57.2 x 77.3 cm.)

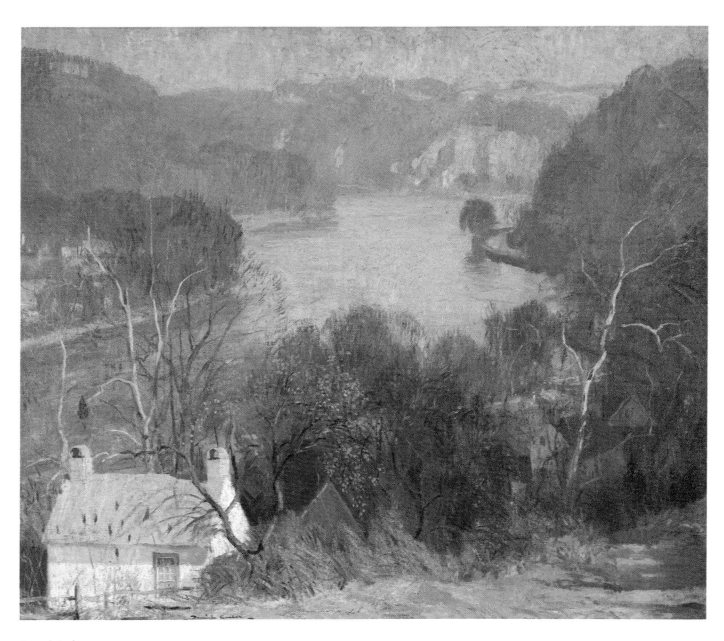

Daniel Garber
Down the River (or Quarry), 1917
oil on canvas
24¼ x 30¼ in. (64.3 x 76.9 cm.)

Donors

CLAREMONT UNIVERSITY CENTER
William Honnold

POMONA COLLEGE
Mrs. Maurice A. Burlinson
Mrs. Julia Benson Tubbs Mann
Alan Matson
Gertrude Coffin Shelton

SCRIPPS COLLEGE
Merle Armitage
Mrs. Henry Everett
Philip H. Gray
Mrs. Eleanor McFee
Vincent Price
Millard Sheets
General and Mrs. Edward Clinton Young
Mr. and Mrs. Steven I. Zetterberg

Acknowledgements

Susan Allen and Ruth Palmer, Libraries of the
 Claremont Colleges
Martha Shipman Andrews, Robin
 Bolton-Smith, and James L. Yarnall,
 National Museum of American Art
Annette Blaugrund, Brooklyn Museum
Doreen Bolger Burke, Metropolitan Museum
 of Art
Nicolai Cikovsky, Jr., National Gallery of Art
Carol Clark, Williams College Museum
 of Art
Abigail Booth Gerdts, National Academy
 of Design
William H. Gerdts, City University of
 New York
Hollis Goodall-Cristante and Michael Quick,
 Los Angeles County Museum of Art
Erica Hirshler, Museum of Fine Arts, Boston
Susan Hobbs, Smithsonian Institution
Peter Jaffe, Pomona College
Henry A. La Farge
Jeffrey Goodhue Legler
Cathrine Leonhard, Mary Leonhard Ran
 Gallery, Cincinnati, Ohio
David N. Mills
Nancy Dustin Mouré
Norman E. Muller, Princeton Art Museum
M. P. Naud, Hirschl and Adler Galleries,
 New York
Maureen C. O'Brien, The Parrish Art
 Musem, Southampton, New York
Patricia Jobe Pierce, Pierce Galleries,
 Hingham, Massachusetts
Richard S. Reid, Belmont, The Gari Melchers
 Memorial Library, Fredericksburg,
 Virginia

Alice M. Reynolds
Angela M. Sciotti, Forbes Library,
 Northampton, Massachusetts
Karen Serota, Detroit Institute of Arts
William S. Talbot, Cleveland Museum of Art
Elizabeth G. de Veer
Abbott Williams Vose and S. Morton Vose II,
 Vose Galleries, Boston
Howard E. Wooden, Wichita Art Museum
Katherine F. Wyant, Potsdam (New York)
 Public Museum
Judith Zilczer, Hirshhorn Museum and
 Sculpture Garden

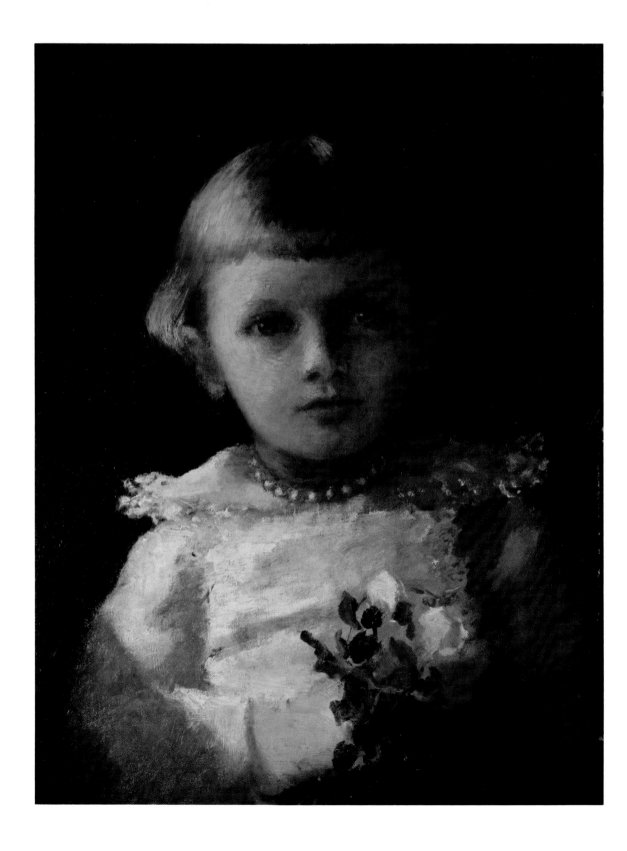

The American paintings included in this catalogue became part of the permanent collections of Pomona and Scripps Colleges through the generosity of a number of donors whose names are listed separately. The great majority were given to Scripps College in 1946 by General and Mrs. Edward Clinton Young, who had developed their extraordinary collection while living in the East. Their goal was to include high quality, representative work by the best American painters active during the period 1870–1930. The collection that resulted is clear evidence of their success.

The Youngs' decision to give their paintings to Scripps College was the result of several factors, including their friendship with Millard Sheets, then chair of the art department, and their admiration for Scripps's innovative humanities curriculum that emphasized the arts. At the time of their gift, the Youngs also supported the general renovation of and creation of new galleries in the Florence Rand Lang Art Building where the paintings were first shown. From the beginning of their discussions with the college, the Youngs were concerned that their paintings be made accessible to the public and particularly to students. In addition to being exhibited regularly on campus through the years, the Young Collection has been shown, in part, in a number of other museums. It has never, though, been so extensively circulated as on the occasion of this exhibition. We feel sure that the Youngs would be pleased to know how widely their cherished collection is now being seen.

That "American Reflections" is traveling nationwide is the result of the interest and support of the Art Museum Association of America. In 1982 Terri Cohn, Curator, first visited Claremont to see the paintings; since that time she and her colleague Harold Nelson, Exhibition Programs Director, have overseen myriad details and have made not only painless but, indeed, pleasurable the complicated task of preparing an exhibition to travel.

Cleaning and conservation of the works in the exhibition were performed by William Leisher, head of the conservation laboratory at the Los Angeles County Museum of Art. Lucy Wolfgang, who spent the summer of 1983 with us as an intern from the Winterthur Program in Conservation, skillfully restored many of the original frames. Funding for conservation was supplied by the Art Museum Association and Gwin Shelton.

This catalogue is the second published by the Galleries this year to deal with an aspect of the colleges' permanent collections. Supported by a grant from the National Endowment for the Arts with matching funds provided by the Fine Arts Foundation of Scripps College, its completion is the result of the work of a great many individuals. Advisors for the writing of the grant application were Nicolai Cikovsky, Jr., William H. Gerdts, and Nancy Dustin Mouré. Ann LeVeque and David Steadman, former Galleries directors, began research on the collections. Entries were prepared by Naomi Sawelson-Gorse, a graduate student in art history at the University of California, Riverside; Kay Koeninger, Curator of Collections; Mary M. Longtin, Registrar; Melinda Lorenz, Curator of Exhibitions; Arthur D. Stevens, Associate Professor of Art, Scripps College; and by myself. Our work was greatly aided by the generous assistance of those in numerous libraries, archives, and museums who have provided important information; their names, too, are listed separately. Steve and Barbara Schenck were responsible for the excellent photography; the manuscript was edited for form by Christine Kopitzke, Director of Publications, Pomona College, and typed by Barbara Senn, the Galleries' Administrative Assistant. The catalogue was designed by Lilli Cristin, whose fine hand is evident in the great majority of our publications.

In collaborative projects of this sort there seems always to be one central figure without whose efforts successful completion would not have been possible. In this case, as with so many of the Galleries' undertakings, that

Abbott Handerson Thayer
Little Girl with Flowers,
c. 1885–90
oil on canvas
18⅛ x 14 in. (46.0 x 35.6 cm.)

person is Kay Koeninger. Kay, who wrote the original grant application shortly before my arrival in Claremont in 1981, has overseen everything from the organization of the exhibition to the concept and final details of the catalogue. While writing a great many of the entries herself, she has gently and effectively kept the rest of us on schedule and has accomplished the delicate task of editing with consummate skill and tact. In my experience, it is rare to find a strong and creative professional, with clearly defined ideas and goals, who accepts the inevitable compromises with grace and humor. All of us involved in this project are grateful to Kay.

The paintings in this exhibition have been treasured and enjoyed by those who collected them and by the colleges fortunate enough to receive them as gifts. It is a pleasure now to offer them to a broader public.

Marjorie Harth Beebe, Director
Galleries of the Claremont Colleges

Contributors

MHB Marjorie Harth Beebe
NSG Naomi Sawelson-Gorse
KK Kay Koeninger
MML Mary M. Longtin
ML Melinda Lorenz
ADS Arthur D. Stevens

*Portraiture,
Landscape and the
Ideal*

Anonymous
19th century

MRS. LAING KNOWLES, C. 1830–40
watercolor on ivory
3⅛ x 2⅜ in. (8.0 x 6.1 cm.)

Pomona College, Gift of Mrs.
Maurice A. Burlinson, 1976

Portraits in the form of miniatures were widespread in the United States in the early decades of the 19th century. Many artists first began their careers as miniaturists. Denied access to other artistic activities, women artists often specialized in miniatures, which were considered an acceptable domestic art.

Mrs. Laing Knowles reflects the changes that occurred in miniatures as bourgeois taste gained influence. In the Revolutionary and Post-Revolutionary eras, miniatures were a provincial version of the type favored by the British aristocracy—generally small, with a thin application of watercolor on ivory, and a pale background. By the early 1830s they grew larger in size; no longer worn in keepsake lockets, they were framed to be displayed on walls and tabletops. The dark background of *Mrs. Laing Knowles* was intended to complement the new setting, as the miniature "had moved from the private precincts of jewelry and the boudoir to the realm of drawing room knicknack."[1]

Mrs. Laing Knowles has been tentatively attributed to George Loring Brown (1814–1889), a Boston painter of miniatures, portraits, and landscapes.[2] The sitter is obviously from a prominent or bourgeois family, and is possibly wearing her wedding dress.[3] The sheen of the lace and ribbons of her gown and the rich red of the background accentuate the healthy glow of her facial tones. Her contentment is skillfully rendered by the artist to produce a charming portrait of a young woman on the verge of smiling. —*KK*

[1] Robin Bolton-Smith, *Portrait Miniatures from Private Collections* (Washington, D.C.: National Collection of Fine Arts, 1976), 6.
[2] Personal letter from Robin Bolton-Smith, May 7, 1984. I am grateful to Dr. Bolton-Smith for her help in my research.
[3] Mrs. Laing Knowles was possibly a member of the prolific Knowles family, who were among the original English settlers of Connecticut in the 1640s. For this information, I am grateful to Katherine Wyant of the Postdam (New York) Public Museum, where there is a collection of Knowles portraits.

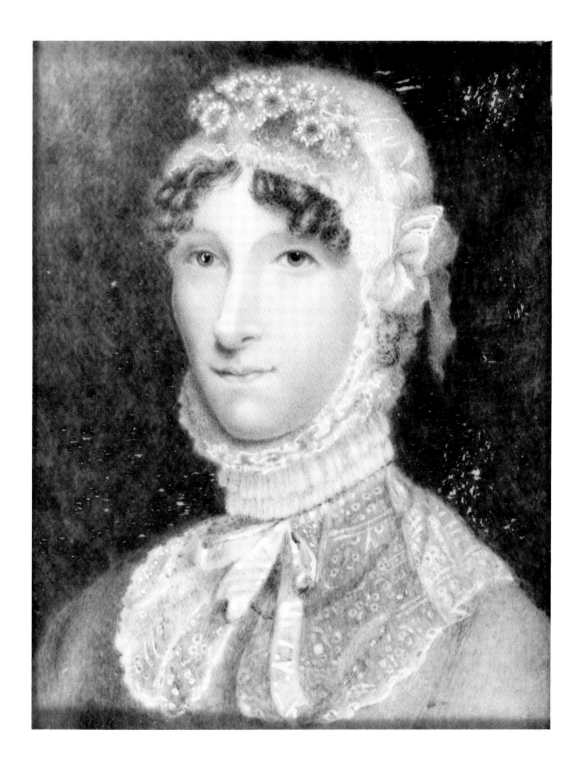

Anonymous
19th century

PORTRAIT OF THEODORE CRANE,
c. 1840
oil on canvas
36 x 29 in. (91.5 x 73.8 cm.)

Scripps College, Gift of Vincent
Price, 1961

The immense popularity of the life-size portrait in the United States before 1845 can be attributed both to the importance of the individual in American culture and to the continued dominance of the British portrait tradition in American art. After 1845, the national credo of Manifest Destiny turned the attention of artists to landscape, which began to supplant portraiture. Photography also contributed to the decline of portraiture, even though the upper classes continued to commission portraits throughout the century.

Theodore Crane is dated c. 1840 because of the sitter's dress. The size of the portrait and the quality of the subject's clothing indicate that he is of some importance. Various aspects of the artist's style—formality, rich color, broadly-applied areas of paint, lack of chiaroscuro, and a noble aura—point to the influence of Gilbert Stuart (1755–1828). Stuart and his successor, Chester Harding (1792–1866), dominated American portraiture during the period 1810–40, especially in Boston.[1] This influence, considered along with the name of the sitter—the Cranes are a well-known Massachusetts family—indicates that the painting may have originated in Boston.

The painting is by an unknown member of the second or third rank of portrait specialists active during the first half of the 19th century. The psychological impact of the sitter's gaze is emphasized by the lack of detail in all areas of the painting except the face. Both the features of the face and the texture of the shirtfront are successfully depicted. However, the tentative rendering of the hand reveals the artist's lack of academic training, which stresses anatomical draftmanship. Because there were only a few established art academies in the United States during this period, most successful or well-connected artists went to Europe to receive their primary education.[2]—*KK*

[1] William H. Gerdts, "Natural Aristocrats in a Democracy: 1810–1870," in *American Portraiture in the Grand Manner,* ed. Michael Quick (Los Angeles: Los Angeles County Museum of Art, 1981), 29–30.

[2] Neil Harris, *The Artist in American Society: The Formative Years 1790–1860* (New York: George Brazillier, 1966), 91–101.

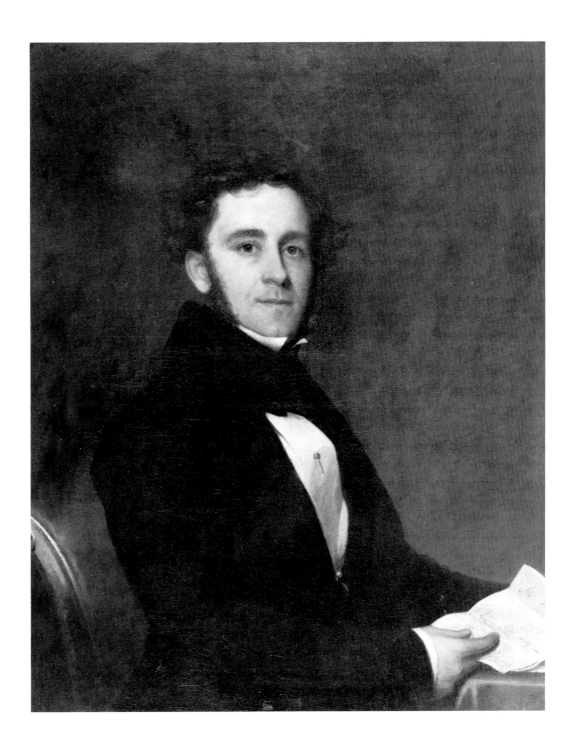

*Anonymous
19th century*

PORTRAIT OF ARNOLD COOK
JANES, 1847
oil on canvas
24 x 20¹/₁₆ in. (61.0 x 51.0 cm.)

Scripps College Collection

Portraits of children have always been popular in American art. Their emotional appeal takes on a deeper meaning in light of the recent discovery that many 19th-century works were painted from the corpses of dead children. Commissioned by families, these "posthumous mourning portraits" were viewed on the anniversary of the child's death and were most popular during the period 1830–60. The portraits acted as important psychological comforts, since the child was always depicted as being alive.[1]

Portrait of Arnold Cook Janes is an important example of a mourning portrait. The symbolism is quite direct: fast-fading flowers ready to be plucked; an ominous dark background with a distant, lighted horizon; traditional mourning colors of white, red, and black; and the suggestion that the child is about to depart. In addition, the child is shown standing on a porch or veranda that symbolizes a state of transition between closed domesticity and the outside world. This spacial construction is, therefore, the appropriate vehicle for indicating a place of the deceased in the mourner's consciousness, for the bereaved understand too well that the dead have departed from their physical space while remaining present in memory.[2] All these elements combine to produce a moving document of 19th-century social life, when infant and child mortality were commonplace.

Arnold Cook Janes of Boston was born on August 23, 1845, and died on September 16, 1847. Another child of the Janes family, also named Arnold Cook, died in 1843 at the age of two. The retailer's stamp on the back of the painting is that of Apollo Morris, whose shop was located at 28 Exchange Street from 1844–48. These dates confirm that the portrait is of the second child, painted shortly after his death.[3] — *KK*

[1] Phoebe Lloyd, "A Young Boy in His First and Last Suit," *The Minneapolis Institute of Arts Bulletin* 64 (1978–80): 105-111
[2] Ibid, 106.
[3] Norman E. Muller, "A Checklist of Boston Retailers in Artists' Materials," *Journal of the American Institute for Conservation* 17 (1977): 61–69. I am grateful to Mr. Muller for sharing his research and making me aware of Dr. Lloyd's article.

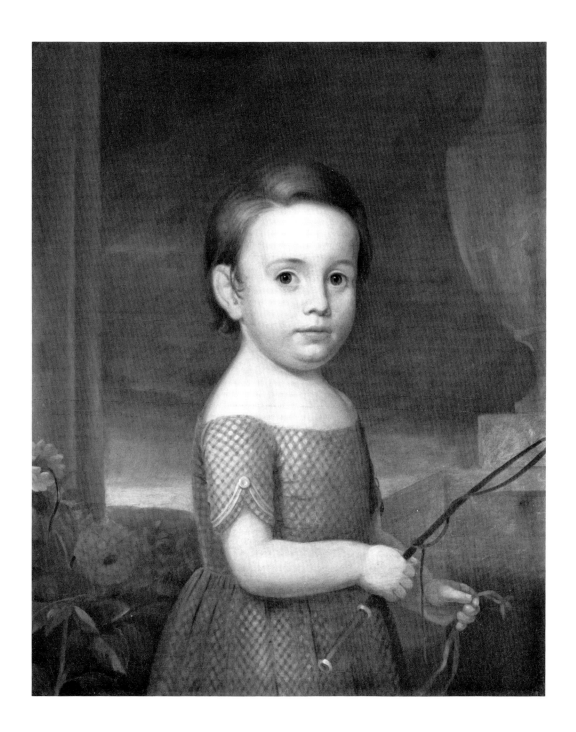

Jasper Francis Cropsey
1823–1900

MOONLIT LAKE, 1865
oil on canvas
11 x 18 in. (28.0 x 46.0 cm.)

Pomona College, Galleries
Purchase with Art Department
Funds, 1966

Jasper F. Cropsey's *Moonlit Lake* beauti-
fully mirrors the 19th-century fascination
with the four seasons and justifies the
artist's fame as a painter of autumn.[1]

The grandson of Dutch immigrant settlers
on Staten Island, Cropsey took his early
training in architectural draftsmanship. He
later studied watercolor but remained largely
self-taught. From 1847–49 he traveled in En-
gland, France, and Italy. During a sojourn in
England that began in 1856, he was exposed
to the precise realism and intense palette of
the Pre-Raphaelites. He returned to the
United States in 1863 to paint scenes of the
Civil War.

Even though Cropsey's work of the 1860s
and 1870s included many large-scale land-
scapes in the style of Albert Bierstadt and
Frederic Church, he continued to produce
small intimate studies like *Moonlit Lake*. Au-
tumn lakes were the artist's favorite subject;
he often depicted them in the idyllic calm and
pristine reflected light of dawn or twilight.
Painted in 1865, *Moonlit Lake* can also be
seen as a respite for the artist from the battle-
grounds and freshly dug graves of the Civil
War that he knew so well.[2]

Moonlit Lake demonstrates how Cropsey,
like many of his contemporaries, attempted
to balance the objective scientific recording of
nature with its subjective romantic interpre-
tation. Although small in scale, the painting
is characterized by the intense topographical
detail and panoramic perspective of the Hud-
son River School. But the emotional poetry
of Luminism is also present, with its mystical
identification of artist and subject. This iden-
tification is intensified by the *plein-air*
painter at work in the lower left hand corner,
overwhelmed by the size of the lake and the
mountain yet at peace with his place in the
natural order. — *KK*

[1] Peter Bermingham, *Jasper F. Cropsey 1823–1900: A Retrospective View of America's Painter of Autumn* (College Park: University of Maryland Art Gallery, 1968), 1–5.

[2] William S. Talbot, *Jasper F. Cropsey 1823–1900* (New York: Garland, 1977), 14, 188. In a letter dated March 30, 1984, Dr. Talbot indicates that the lake in the paint-ing is possibly located in northeastern Pennsylvania near the Susquehanna Valley, where the artist worked on his large and well-known oil *Starrucca Viaduct*, 1865.

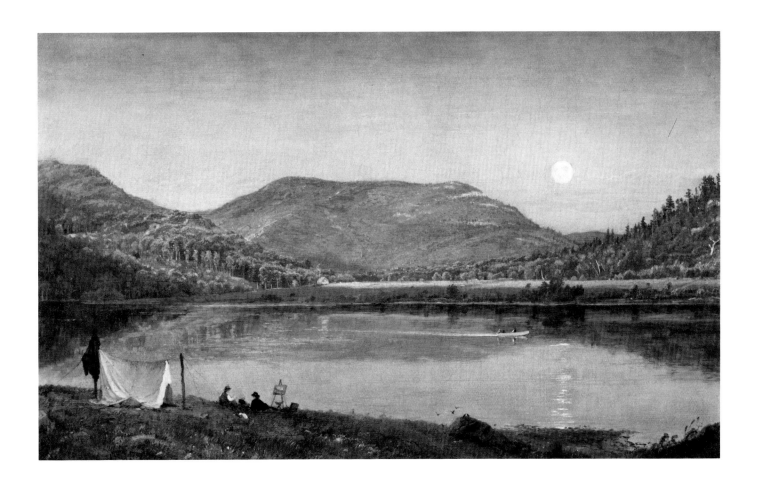

George Inness
1825–94

MEDFIELD LANDSCAPE
(or CLEARING), c. 1863–65
oil on canvas
22 x 30 in. (55.8 x 76.2 cm.)

Pomona College, Bequest of
Clyde Alan Matson, 1962

George Inness, the son of a grocer, was raised in Newark, New Jersey. His training as an artist was sporadic and included a stint as an apprentice engraver. More important to his career were early and frequent trips to Europe.

Inness studied the work of the Barbizon School while spending a year in France, and many of his paintings from the 1850s and 1860s, including *Medfield Landscape*, directly relate to the Barbizon aesthetic. *Medfield Landscape* differs from the artist's earlier realist style in the freer handling of paint; in its brighter, less harmonious colors; and in its tone of intimacy and informality. It was painted shortly after Inness moved from the Massachusetts village of Medfield to the New Jersey estate of Eagleswood, the former site of the Raritan Bay Union communal society. It was in Eagleswood that Inness came in contact with the teachings of the 18th-century Swedish mystic Emanuel Swedenborg.

In the 1860s Inness became friends with Henry Ward Beecher, whose writings often express the Transcendentalist obsession with nature as a representation of divine immanence and meaning. The artist often explored these tenets: in *Medfield Landscape* a mystical glow, partially obscured by the central grove of trees, suffuses the entire composition. [1]

Inness was also concerned with more worldly matters. A committed abolitionist, he was prevented from enlisting in the Union Army because of ill health. *Medfield Landscape*, painted at the height of the Civil War, is perhaps his paean to peace and tranquility in the midst of the ominous storm clouds of war. —*KK*

[1] Nicolai Cikovsky, Jr., *George Inness* (New York: Praeger, 1971), 35–36.

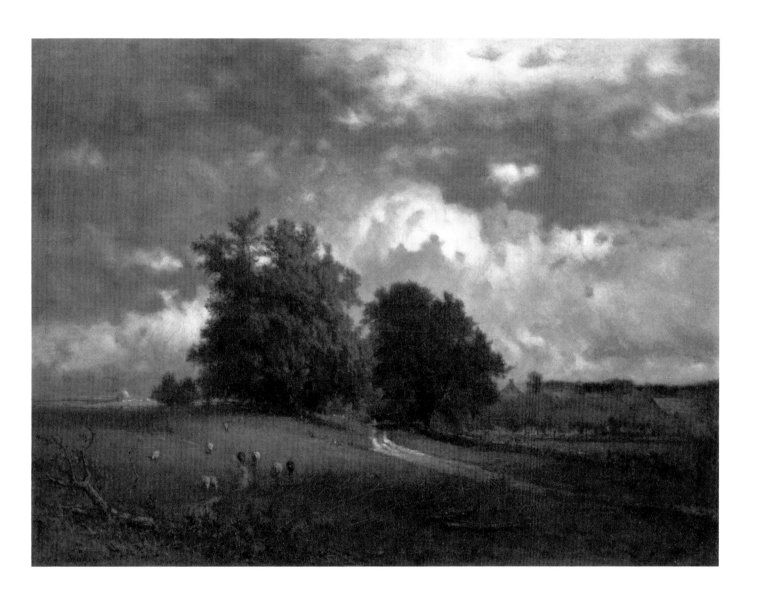

George Inness
1825–94

ON THE PEQUONIC (or PEQUONIC
RIVER, POMPTON, NEW JERSEY),
1877
oil on canvas
11 x 13½ in. (28.0 x 34.3 cm.)

Scripps College, Young
Collection, 1946

The years 1870–84 represent the richest and most active period in George Inness's art. He spent the first five of these years in Europe, primarily in Italy and France. *Pequonic River* dates from the 1870s, when Inness began to use a richer, deeper palette and freer brushwork than in his earlier paintings. A decorative, two-dimensional quality shows the artist's awareness of Whistler's Orientalism.

Inness was an intensely religious man and he became a dedicated student of Swedenborgianism during the last decades of his life. Swedenborg's writings describe a spiritual world that closely resembles the natural world, characterized by intense color, unfixed distances, and substance replacing solid matter. It is unclear precisely how Swedenborg influenced Inness's art, but the artist's later paintings, including *Pequonic River*, can be viewed as poetic renderings of a different reality. They are often incorrectly classified as "Impressionist." Inness was never concerned with the scientific study of light or strict *plein-air* technique that produced what he called the "vulgarity of overstrained objectivity."[1]

Pequonic River can also be considered an early example of Tonalism, the late 19th-century romantic American style characterized by diffused light, subtle coloration, and a nostalgic mood of reverie. Human figures are never active participants in Tonalistic paintings. Like the solitary fisherman in *Pequonic River* they are only bystanders, seemingly lost in a dream. —*KK*

[1] George Inness, Jr., *Life, Art, and Letters of George Inness* (New York: The Century Co., 1917), 169.

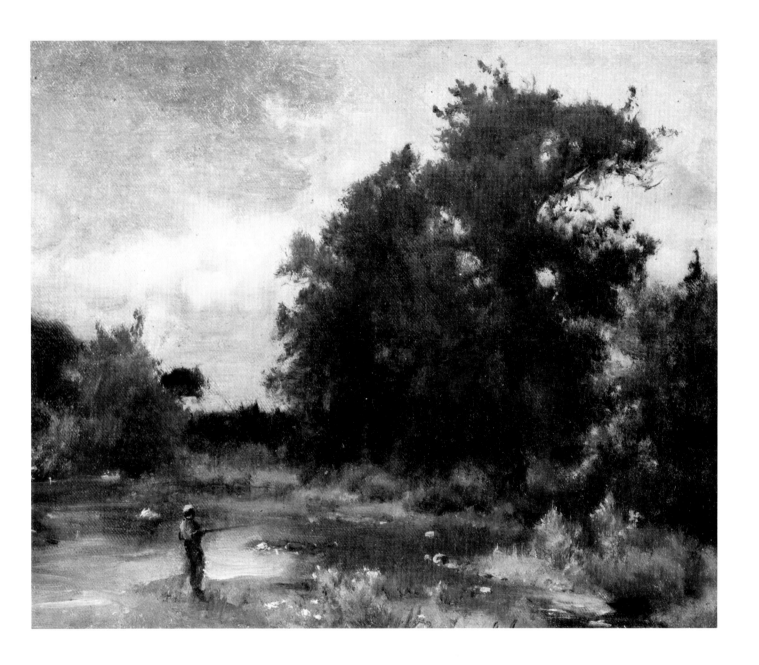

Ralph Albert Blakelock
1847–1919

LATE APRIL, C. 1880–90
oil on canvas
16 x 24 in. (40.7 x 61.0 cm.)

Scripps College, Young
Collection, 1946

Ralph Albert Blakelock, born in New York, is considered to be one of the most gifted of self-taught American artists. While in conflict with his parents over his choice of an artistic career, Blakelock traveled in the West and Mexico during the years 1869–71. This trip produced the sketches that became the foundation of his entire *oeuvre*. Little is known about the journey (the dates are not certain and Blakelock may have made a second trip in 1872), as he traveled alone and spent most of his time in isolated Indian settlements.

The artist returned to New York and married in 1873. Blakelock and his wife had a large family and it was a continual struggle to support themselves through his art. During the 1870s Blakelock abandoned his earlier Hudson River School realism and slowly forged a painterly, unorthodox style drawn from his intensely personal vision of the landscape:

> His forms became more simplified over the years as ideas were borrowed from nature and reinvented, and many of his pictures seem, in their remote stillness, to be dreamed rather than seen.[1]

After the early 1870s Blakelock no longer dated his work. *Late April* can be dated to the 1880s or 1890s because of its size and its composition of horizontal bands: an empty foreground, a screen of trees, and a distant horizon filled with glowing light. Like many of Blakelock's later paintings, *Late April* can be called a "skyscape"—the sky is the main subject and the contrast of the dark, spidery branches of the trees against the light provides the major interplay of form.[2]

Blakelock's paintings, with their limited palette, spontaneous handling of form, melancholy tone, and lack of drama, were virtually ignored by the American art establishment until the late 1890s. By the time recognition finally came, financial and psychological strains had taken their toll and Blakelock was showing signs of schizophrenia. Unaware of his success, he was confined in a succession of mental institutions until his death. —*KK*

[1] David Gebhard and Phyllis Stuurman, *The Enigma of Ralph Albert Blakelock* (Santa Barbara: University of California Art Galleries, 1969), 6.
[2] Norman Geske, *Ralph Albert Blakelock* (Lincoln: University of Nebraska, Sheldon Memorial Art Gallery, 1975), 29.

William Keith
1839–1911

MT. TAMALPAIS (or CALIFORNIA
LANDSCAPE), 1893
oil on canvas
30½ x 47½ in. (77.5 x 120.6 cm.)

Claremont University Center,
Gift of William Honnold

The prolific San Francisco artist William Keith was the most influential painter in California during the last decades of the 19th century. *Mt. Tamalpais* is an important example of one of the two phases of Keith's mature work.

Trained as an engraver and influenced by the Hudson River School, Keith gained success in the 1870s for his panoramic glorified landscapes of the High Sierrra. These paintings were a result of long hikes in the area with his life-long friend and fellow Scotsman, the naturalist John Muir. By the mid-1880s Keith's landscapes began to show the influence of Barbizon.

Mt. Tamalpais, painted in 1893, is primarily Barbizon in feeling, with its intimate and lyrical mood and narrow tonal range. However, the poetic and vaguely spiritual mauve light of the hazy mountain peak points to the aesthetic of Inness, who visited Keith for two months in 1891, and to Keith's own growing involvement with Swedenborgianism. These new influences would culminate by the mid-1890s in the final stage of Keith's art—small, dark, brooding landscapes of the imagination, semi-abstractions using large blocks of color and blurred shadows.[1]

Mt. Tamalpais is the highest mountain (elevation 2,600 ft.) on the west side of San Francisco Bay. Named after the Spanish word for the Miwok Indians, it overlooks the famous redwoods of the Muir Woods, created as a forest reservation in 1896 through the efforts of John Muir and other California conservationists. The mountain was apparently a favorite subject of the artist, for it appears in several of his paintings.[2] —*KK*

[1] Raymond L. Wilson, "William Keith, 1838–1911," in *William Keith: A Changing Vision*, ed. Kathryn Funk (Fresno, California: Fresno Art Center, 1984), unpaginated.
[2] Ibid. and Eugen Neuhaus, *William Keith: The Man and the Artist* (Berkeley: University of California Press, 1938), 13.

Thomas Moran
1837–1926

STORM AT SEA, CORNWALL,
ENGLAND, C. 1906–10
oil on paper
6⅛ x 11⅛ in. (15.5 x 28.3 cm.)

Scripps College, Young
Collection, 1946

Thomas Moran is best known as one of the foremost painters of the American West, especially of Yosemite, Yellowstone, and the Grand Canyon. However, despite his primary subject, his art remained firmly grounded in the English painting tradition of Turner.

Moran, born in England, was apprenticed at a young age to a wood engraver in Philadelphia. He left the engraver while still a teen-ager to devote himself to painting, in which he was self-taught. Moran's first exposure to Turner came about when the young artist traded one of his watercolors for a book of Turner engravings. In the years that followed, he became like Turner, "a tireless traveler in the search for nature's variety."[1] Moran's first trip to England, in 1861, was for the purpose of studying Turner's paintings and sketching many of the harbors that had interested Turner.[2]

Like Turner, Moran often emphasizes the violent aspect of nature, exemplified by stormy seas, shipwrecks, and small boats tossed on waves. This debt is evident in *Storm at Sea*, which is also characterized by Turner's radiant color, dynamic motion, atmospheric intensity, and small human fig-ures. *Storm at Sea* can be tentatively dated in the period 1906–10, when Moran made two trips to England and sketched in Cornwall. It was during this time that he once again painted marines after three decades of producing wilderness landscapes.

Storm at Sea is identical in composition, subject, and format to an earlier work, *The Much Resounding Sea* (fig. 1), which is probably related to Moran's lost large-scale painting *Abandoning Waterlogged Vessel, Easthampton, L.I.* Research has shown that the painting, dated 1885, did not document a specific disaster. Though a vigorous *plein-air* painter, Moran, like Turner, often drew upon a well-developed romantic imagination.[3] —*KK*

[1] Thurman Wilkins, *Thomas Moran: Artist of the Mountains* (Norman: University of Oklahoma Press, 1966), 7.
[2] It is known that Moran owned a copy of Turner's *The Harbors of England*, a book of engravings made from his sketches. See Maureen C. O'Brien and Patricia C. F. Mandel, *The American Painter-Etcher Movement* (Southhampton, New York: The Parrish Art Museum, 1984), 38–39.
[3] Ibid. I am grateful to Ms. O'Brien for sharing her research and for pointing out the connections between *The Harbors of England*, the Parrish Museum etching, and the Scripps College painting.

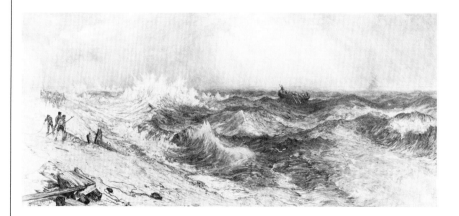

FIG. 1 Thomas Moran, *The Much Resounding Sea*, 1886, etching, The Parrish Art Museum, Southampton, New York, Dunnigan Collection

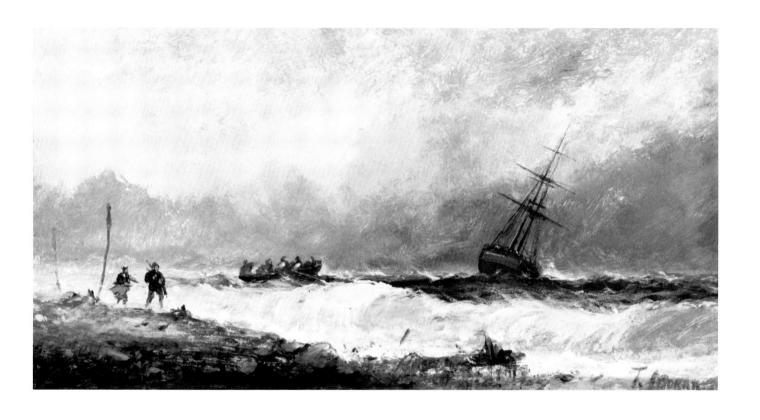

M. Howard
19th century

STILL LIFE WITH GRAPES,
c. 1880–90
oil on canvas
14 x 20⅛ in. (35.6 x 51.1 cm.)

Pomona College, Gift of Mrs.
Julia Benson Tubbs Mann, 1967

The tradition of still life painting is important in the United States, partly because the "respect for fact, whether object or place. . .characterizes so much American art."[1] A complex reflection of social and economic conditions, myths, and cultural values,[2] the still life was the subject of an almost unbroken tradition throughout the 19th century. Many aspects of *Still Life with Grapes*—its small intimate arrangement, uncovered plain shelf, perfect shapes, and dark neoclassical background—point to the influence of Raphaelle Peale (1774–1825), America's first professional painter of still lifes.

The genre reached its greatest popularity after 1860. Particularly when it included fruit, the still life reflected the national myth that America was a natural paradise given by God to his chosen people. Still lifes were increasingly accepted as the proper art to be hung in domestic interiors, especially dining rooms.[3] *Still Life with Grapes* depicts two fruits popular at mid-century—grapes (symbolic of Christianity) and peaches. The small basket of raspberries perhaps indicates the artist's awareness of the still lifes of George Henry Hall (1825–1913), who was known for his similar depictions of that fruit.

The painter of *Still Life with Grapes* was obviously a trained artist. The modeling of the forms, placement of shadow, and effective depiction of semi-transparent liquid in glass create a pristine composition of evocative objects. The painting demonstrates well a tradition that produced "unpretentious celebrations of daily realities and familiar things."[4]

The straightforwardness, simplicity, and almost awkward strength of *Still Life with Grapes* is characteristic of the middle of the second half of the century. It may be the work of Mary R. Howard, later Mrs. Bradbury or Brodbury (1864–?), a painter born in Cambridge, Massachusetts, who studied in New York and Paris and appears to have been active in Berkeley, California.[5] This attribution is partially supported by the fact that women have a long tradition, going back to 17th century Holland, as still life painters. —*KK*

[1] Barbara Novak, *American Painting of the Nineteenth Century* (New York: Praeger, 1961), 221.
[2] William H. Gerdts, *Painters of the Humble Truth: Masterpieces of American Still Life 1801–1939* (Columbia: University of Missouri Press, 1981), 23
[3] Gerdts, "Nature's Bounty: Early American Still Life Painting," *Portfolio* 3 (Sept.–Oct. 1981): 62–65.
[4] John Wilmerding, "The American Object: Still-Life Paintings," in *An American Perspective*, ed. John Wilmerding (Washington, D.C.: National Gallery of Art, 1981), 86.
[5] For help with dating and attribution I am grateful to William H. Gerdts and S. Morton Vose II.

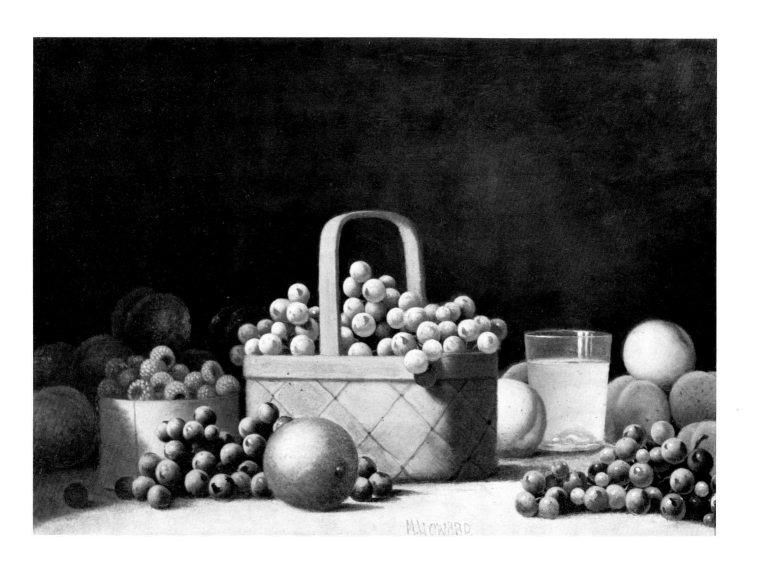

Elihu Vedder
1836–1923

THE FLOOD OF 1870 (or THE TIBER
AT FLOOD, ROME), c. 1870
oil on paper
10¼ x 14¼ in. (25.9 x 36.2 cm.)

Scripps College, Young
Collection, 1946

The Flood of 1870 documents the disastrous flood that struck Rome in December, 1870, a few months after the city had become the capital of the newly-formed Kingdom of Italy. Carrie Vedder, the artist's wife, wrote "I can give you no idea of the excitement and the scene...About one third of Rome is overflowed and the water is rising."[1]

The Vedders were in their first year of marriage and had come to Rome to join the large Anglo-American community of artists and writers that included John Singer Sargent, Edith Wharton, William S. Haseltine, and Henry James. For many expatriates Rome was the aesthetic antidote to the increasing industrialization and commercialization of the late 19th century. Even though he made frequent trips to New York, Vedder lived chiefly in Rome until his death.

Throughout his career Vedder was torn between his personal preference for landscape and visionary subjects and collectors' demands for antiquarian-style paintings in the Pre-Raphaelite manner. His landscapes were influenced by the "Macchiaioli," young Italian landscape painters working in Florence, where Vedder lived from 1857 to 1860. *The Flood of 1870* is characterized by the Macchiaioli-like use of unmodulated areas of color, sharp contrast between light and shade, and emphasis on luminous effect at the expense of detail.

The Flood has the personal poetic quality and brooding lyricism that is found throughout Vedder's *oeuvre*. It depicts an actual event, but also is concerned with what Melville called "the significance that lurks in all things."[2] — *KK*

[1] Regina Soria, *Elihu Vedder: American Visionary Artist in Rome* (Rutherford, New Jersey: Fairleigh Dickinson University Press, 1970), 74.
[2] Regina Soria, "Introduction," in *Perceptions and Evocations: The Art of Elihu Vedder*, ed. Joshua Taylor (Washington, D.C.: National Collection of Fine Arts, 1979), 31.

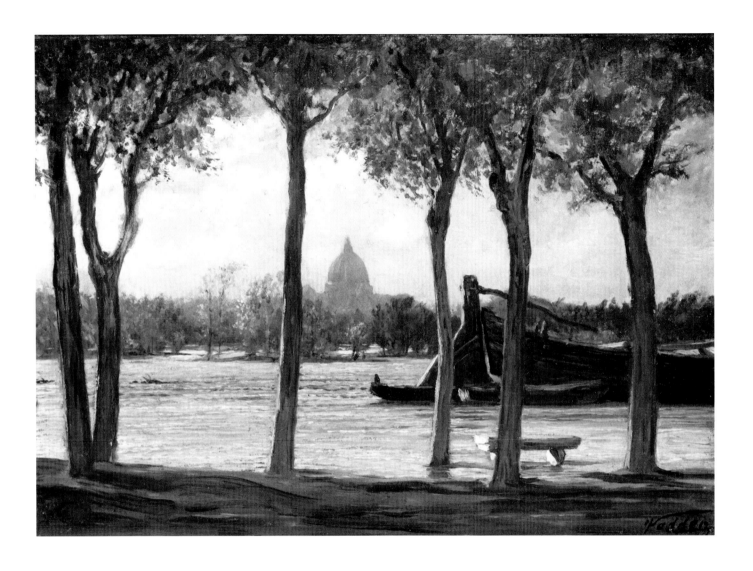

Elihu Vedder
1836–1923

SHEPHERDS PIPING (or LAND-
SCAPE WITH BOY PIPING),
c. 1870–1911
oil on mahogany panel
4⅛ x 13⅝ in. (10.5 x 34.6 cm.)

Scripps College, Young
Collection, 1946

Landscape was a life-long interest of Vedder, even though his fame rests on such mythical and literary works as *The Questioner of the Sphinx, The Lair of the Sea Serpent,* and the illustrations for an 1886 edition of the *Rubáiyát* of Omar Khayyám. He began to paint landscapes seriously in 1865; deeply affected by a trip to Perugia in 1867, he developed an intense interest in the effect of light on the plains and mountains of central Italy. The artist returned to Perugia in the summer and fall for many years.

Shepherds Piping is one of many small landscape studies Vedder produced. Showing his debt to the Macchiaioli, it captures the flat patterns of color and light on the Italian hills, their forms accentuated by sharp contrasts between sun and shadow. A substantial part of the Macchiaioli aesthetic was anti-tradi-tional; following this tenet, Vedder rejected the academic triangular composition and con-structed a narrow horizontal panorama.[1]

By 1870 Vedder had acquired a full reper-toire of landscape motifs that he reworked and repeated in later paintings. *Shepherds Piping* is clearly inspired by the open spaces and hills of Umbria and Tuscany, while the two figures, evoking mythical and pastoral themes, are products of the artist's imagina-tion. The world Vedder depicts is one of poetry and is only vaguely historical:

> There is no story to tell, and yet the senses and the imagination are trans-ported to an arrested eddy of time in which their exercise had full rein.[2]

In the reaction against late Victorianism, Vedder was largely forgotten. Most of his work (including *Shepherds Piping* and *The Flood of 1870*) remained in the possession of his daughter Anita. However, the present re-evaluation of 19th-century Romanticism has caused a new interest in Vedder, whose use of object as symbol and metaphor prefigures the Surrealism of the 20th century. —KK

[1] Joshua Taylor, "Perceptions and Digressions," in *Perceptions and Evocations,* 38–43.
[2] Ibid., 77

36

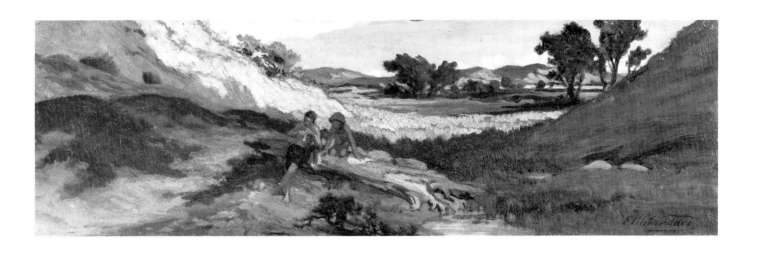

John La Farge
1835–1910

PSYCHE (OR TWO LOVERS),
c. 1870–74
oil on wood panel
16 x 8 in. (40.8 x 20.4 cm.)

Scripps College, Young
Collection, 1946

John La Farge, a prominent and well-traveled member of the "Boston Circle" that included Henry and William James, Henry Adams, William Morris Hunt, and Stanford White, is best known for his murals, stained glass, and book illustrations. In addition to his art, La Farge wrote extensively on aesthetics and color theory, and inspired by the Arts and Crafts movement like many of his contemporaries, he allowed his wide eclecticism to divert him from formulating a vigorous personal painting style. According to his biographer, at the end of his life La Farge regretted that he had not concentrated on painting.[1]

Psyche can be dated from the period 1870–74, when La Farge was turning from landscape painting to figural subjects, particularly those drawn from classical mythology. It depicts the maiden loved by Cupid, or Eros. Cupid came by night and admonished his lover never to find out his identity. Curiosity overcame her and she discovered that he was a god; angered, he abandoned her. Psyche went through a series of hardships before she was reunited with Cupid and subsequently made immortal. The subject of *Psyche* is confirmed by its preparatory drawing (fig. 2), which shows the male figure with his customary wings.[2] The psychological impact of the painting is deepened by the obscured face of Cupid, the dark, ominous background, and the glowing, ethereal colors.[3]

The provenance of *Psyche* documents important stages in La Farge's career. Its first owner was Henry Hobson Richardson, the famous architect who designed Trinity Church in Boston and commissioned La Farge to paint murals for it in 1876. John Chipman Gray, the second owner, was a wealthy Massachusetts legislator who was the artist's early patron.[4] — *KK*

[1] Royal Cortissoz, *John La Farge: A Memoir and a Study* (Boston: Houghton Mifflin, 1911), 211.

[2] Personal letters from Henry A. La Farge, dated August 23, 1975, and May 13, 1983. I am grateful to Mr. La Farge, grandson of the artist, who is preparing the La Farge catalogue raisonné, for sharing his research and making me aware of the Berea College drawing.

[3] *Psyche* can be compared with Robert Loftin Newman's *Madonna and Child* in the Scripps College collection. Both artists developed a strong interest in color as students of Thomas Couture.

[4] Henry A. La Farge, "John La Farge and the 1878 Auction of His Works," *American Art Journal* 15, no. 3 (Summer 1983): 34.

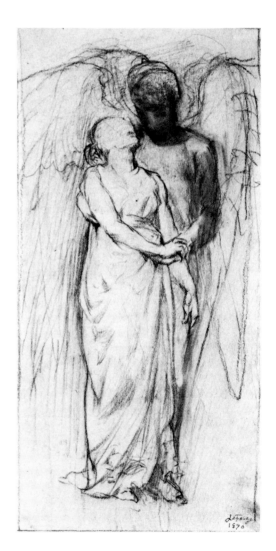

FIG. 2 John La Farge, *Psyche*, 1870, crayon on paper, Berea College, Berea, Kentucky

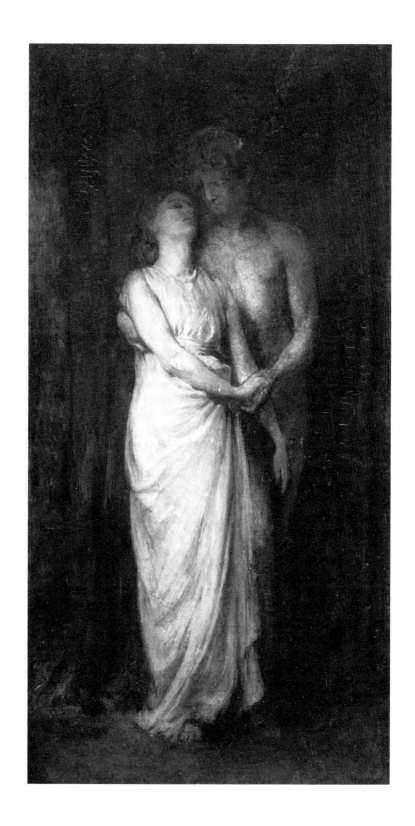

Homer Dodge Martin
1836–97

GOLDEN SANDS (VILLERVILLE, NORMANDY), 1883
oil on canvas
15½ x 24½ in. (39.4 x 62.2 cm.)

Scripps College, Young Collection, 1946

Homer Dodge Martin's *Golden Sands* was painted during the period 1881–89 when the artist and his wife lived on the French coast. It was a happy period for Martin and his family; his wife, the writer Elizabeth Gilbert Martin, later reflected, "I look back on the time we spent in Villerville as the most tranquil and satisfactory period of our life together."[1] Upon their return to the United States, Martin's illnesses—including cataracts and alcoholism—caused increasing burdens.[2]

Martin was plagued by low productivity throughout his career; his wife's writing was their main financial support. However, the period in France was important for the absorption of impressions that the artist used in later work. *Golden Sands* is a small finished version of one of the figures in Martin's important painting *The Mussel Gatherers* (fig. 3), which has been described as

> typical of Martin's understated impressions of that area's [Normandy's] raw coastline. A first glance offers little more than a gloomy dunescape under a dense sky with two fisherwomen—figures suggesting neither heroic toil nor artful

insertions in the composition, but merely hinting at the nature of the locale and revealing something of the scale of the scene.[3]

Several features of *Golden Sands*—its poetic withdrawal, lack of detail, silhouetted figure, and wide, balanced spaces—are also often found in landscapes painted by Martin's friends La Farge and Whistler in the 1860s. The subtle coloration of the background points to the influence of Boudin and Corot.

Like many other artists in the second half of the 19th century, Martin was distracted by an internationalism that prevented him from formulating a consistent style of his own. His landscapes can be viewed today as well-crafted and evocative examples of that era's romantic attempt to find meaning in nature. —*KK*

[1] Elizabeth Gilbert Martin, *Homer Martin: A Reminiscence* (New York: William MacBeth, 1904), 27.
[2] Patricia C. F. Mandel, "The Stories Behind Three Important Late Homer D. Martin Paintings," *Archives of American Art Journal* 13 (1973): 2.
[3] Peter Bermingham, *American Art in the Barbizon Mood* (Washington, D.C.: National Collection of Fine Arts, 1975), 61.

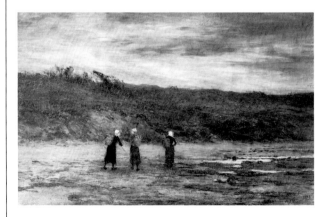

FIG. 3 Homer Dodge Martin, *The Mussel Gatherers*, 1886, Corcoran Gallery of Art, Washington, D.C., Bequest of Mrs. Mabel Stevens Smithers

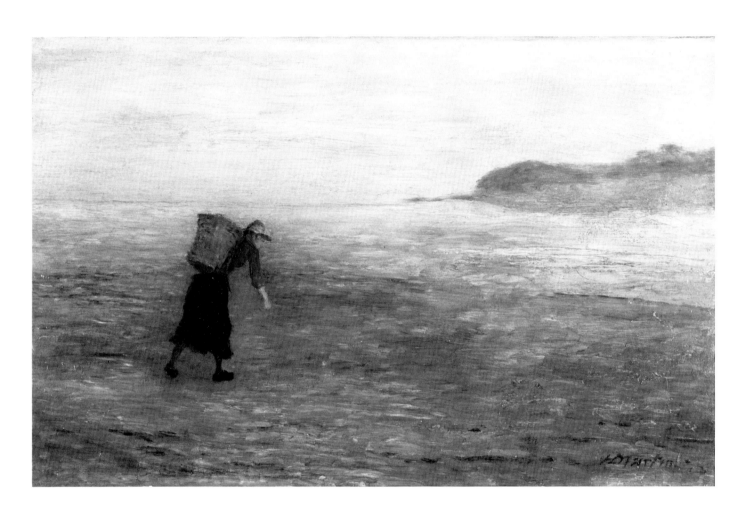

Robert Loftin Newman
1827–1912

MADONNA AND CHILD,
c. 1894–1900
oil on canvas
16¹⁄₁₆ x 12¹⁄₁₆ in. (40.8 x 30.6 cm.)

Scripps College, Young
Collection, 1946

Robert Loftin Newman remains one of the most elusive figures in 19th-century American art. The artist, who spent his childhood outside Nashville, Tennessee, and most of his adult life in New York, was a virtual recluse who had only one exhibition during his lifetime. Mistakenly referred to by many critics as an unsophisticated "painter of dreams," Newman actually explored subject matter and aesthetic concerns drawn directly from the history of art.

Early in his career Newman studied in Paris with Thomas Couture, a follower of Delacroix who stressed color, light, and vigorous brushstrokes over line and the finished articulation of form. This emphasis is evident in *Madonna and Child,* with its intense areas of color balanced by shadow, its rapidly-applied glazes, and its blurred figural outlines. The application of color creates a strong psychological impact despite the small scale of the painting.

Madonna and Child was produced after 1882, during the period when Newman concentrated on religious themes, especially the sacred version of the mother and child.[1] In the late 1870s many American artists had become interested in religious subjects, a result of the growth of the American Arts and Crafts movement and the subsequent success of La Farge's church murals in Boston and New York. Newman had worked in the early 1870s as a stained-glass designer for Francis Lathrop, a leader of the Arts and Crafts movement and a former student of the Pre-Raphaelites Ford Maddox Brown and William Morris. The inner glow of the rich reds and yellows in *Madonna and Child* reflects the artist's experience in Lathrop's New York studio.

Newman, who never married and had no children, painted numerous versions of the mother and child during his career. His unique interpretation of the theme almost always includes a gesturing infant:

The child reaches out, one arm extended, as if to point a way beyond the protective embrace of the mother, and the equally protective shelter of the trees. . . With Newman, it is a poetic portent of things to come.[2] — *KK*

[1] The Scripps College *Madonna and Child* can be tentatively dated 1894–1900, based on a comparison with similar paintings. See Marchal E. Landgren, *Robert Loftin Newman: 1827–1912* (Washington: National Collection of Fine Arts, 1974), 130–33.
[2] Ibid., 72.

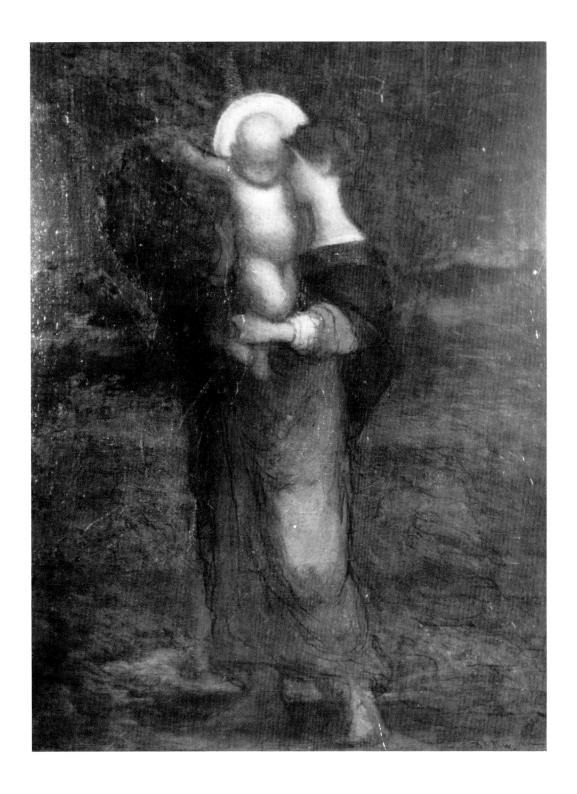

*George Fuller
1822–84*

IDEAL HEAD, c. 1874–1884
oil on wood panel
12¼ x 12⅛ in. (31.1 x 30.8 cm.)

Scripps College, Young
Collection, 1946

An iconoclast who did not have a conventional artistic career, George Fuller was nonetheless greatly acclaimed during the last decades of his life. Along with La Farge, Newman, Vedder, and Blakelock, he represents the extreme romanticism of the late 19th century.

Fuller studied with his brother, an itinerant portrait painter, and at the National Academy of Design. He worked as a portraitist until 1860, when the death of his father forced him to manage the family farm in Deerfield, Massachusetts. Because of his aversion to academic conformity and his deep individualism, Fuller did not resent his rural isolation. He continued to paint, even though he did not become fully active until the Panic of 1873 caused him to hold a sale of his works for the refinancing of the farm. Fuller was associated with the Barbizon painters William Morris Hunt and J. Appleton Brown in Boston.

Ideal Head, one of several that Fuller painted, appears to be unique among the group in its depiction of a profile. In the style of Fuller's last decade, the color is dense and bituminously murky with an overall evocative haze. The facial contours are blurred by the rich layering of thick, textured paint. As in many of Fuller's portraits, the subject is a young, idealized woman, "a type that may well stand for American, New England girlhood."[1]

In the late 1870s Fuller and his contemporaries were

> materializing their personal visions, through abstract, pictorial language, using as motifs both pure landscape and the figure...By that time subjectivity and poetic generalization had begun to achieve preeminence as the expression of a modern spirit in painting.[2]

Fuller's reputation declined after the 1920s. Today, however, his charm, subtlety, and mystery are once again valued. —*KK*

[1] Press clipping, *The Boston Transcript*, 5 March 1881, Fuller Papers, Private Collection, quoted in Sarah Burns, "A Study of the Life and Poetic Vision of George Fuller," *The American Art Journal* 13, no.4 (Autumn 1981): 35. I am also grateful for information about the Scripps *Ideal Head* from Jeffrey Goodhue Legler, great-great-grandson of the artist.
[2] Sarah Burns, "Life and Poetic Vision of George Fuller," 34.

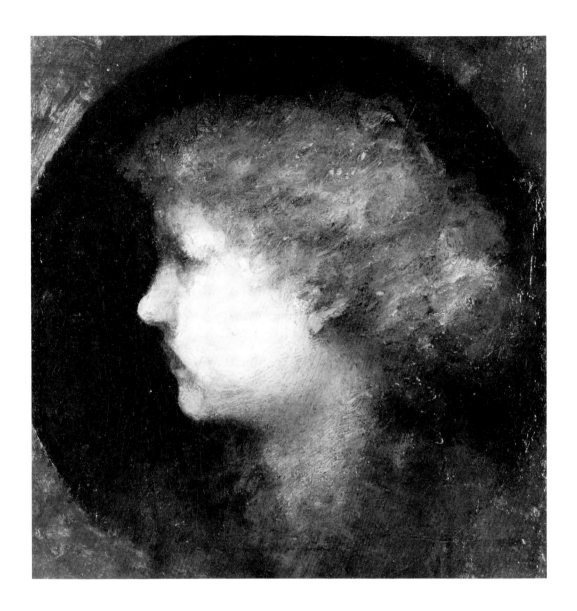

Elliott Daingerfield
1859–1932

OFFSHORE WIND, C. 1905–15
oil on canvas
6 x 9 in. (15.3 x 22.9 cm.)

Pomona College, Gift of Gertrude
Coffin Shelton, 1977

The son of a Confederate Army officer, Elliott Daingerfield grew up in Fayetteville, North Carolina. In 1880 he went to New York, where he exhibited and studied at the Arts Students League and the National Academy of Design. New York remained his permanent home, though he spent summers in his native state. He worked at the famous Holbein Studios on West 55th Street along with such artists as Inness, Martin, Henry Ward Ranger, and J. Alden Weir. It was from his good friend Inness (Daingerfield would later become Inness's biographer) that he learned the technique of layering color with thin coats of varnish to produce the rich glow of many of his paintings, including *Offshore Wind*.

During his career, Daingerfield explored many styles—Barbizon, Pre-Raphaelite, Decorative Impressionist, and Tonalist. His early pastoral depictions were a result of his rural upbringing and the strong Barbizon influence of Ranger.[1] Daingerfield later produced landscapes of pure imagination, usually of a religious or poetic nature.

Offshore Wind can be dated 1905–1915 from its subject and technique. Raging seas are often found in Daingerfield's later work; the most well-known example is *Christ Stilling the Tempest* of 1905–10. But the violence is highly lyrical: even though *Offshore Wind* is an illustration of a storm, "thick and thin waves of pigment seem to be applied with an indolent gesture, which helps to impart to the canvas a hazy, dream-like quality."[2]

The standing nude framing the composition on the left indicates Daingerfield's skill as a draftsman (during 1902–07 he produced large figural murals for the Church of St. Mary the Virgin in New York). After 1906 he emphasized color—usually rich greens, reds, and blues in the same tonal range—over figure, and many of his later paintings are characterized by an aura of movement comparable to that in Ryder's work.[3] However, Daingerfield continued to employ the nude, with its allegorical and metaphorical connotations, as a secondary element in some of his landscapes. —*KK*

[1] Bermingham, *American Art in the Barbizon Mood,* 130.
[2] Robert Hobbs, *Elliott Daingerfield Retrospective Exhibition* (Charlotte, North Carolina: Mint Museum of Art, 1971), 50.
[3] Ibid., 34.

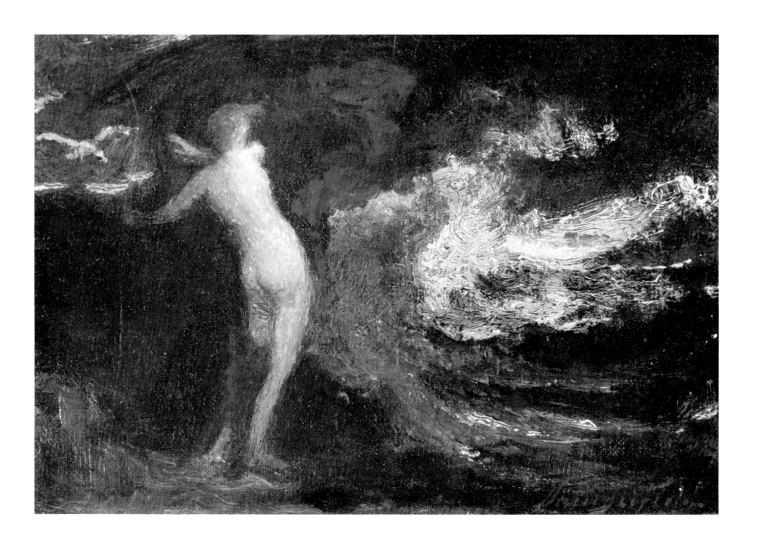

Major American Impressionists

Mary Stevenson Cassatt
1844–1926

SMILING SARAH IN A HAT
TRIMMED WITH A PANSY (BESS
WITH DOG), c. 1901
oil on canvas
26½ x 22½ in. (67.3 x 57.0 cm.)

Scripps College, Young
Collection, 1946

The designation of Mary Cassatt as an American Impressionist requires refining. American by birth, she spent most of her life in France; associated with the French Impressionist painters to a greater extent than any of her compatriots and clearly influenced by them, she was, above all, a figure painter in whose work line, form, and composition were always of greater concern than color and light. Her relationship to Impressionism was similar to that of Degas, a friend, mentor, and admirer of her work who invited her to exhibit with the *Indépendents*. She commented later:

> finally I could work independently without taking into account the opinion of the jury. I had already recognized my true masters... Manet, Courbet, and Degas. I hated conventional art; I began to live.[1]

Cassatt had received academic training at the Pennsylvania Academy and in Paris, and, despite her impatience with academic art, there is an underlying classicism throughout her work, revealed in carefully controlled drawing and clear definition of form. A fascination with Japanese prints that she shared with Degas is reflected in her use of line as well as in her compositions.

Single and childless, Cassatt devoted much of her *oeuvre* to mothers and children. Despite the inherent emotion of this subject, the formal strength of Cassatt's art always saved it from sentimentality. *Smiling Sarah*, one of more than forty paintings, pastels, and drawings of the same model, exemplifies this. The figure of Sarah, identified as the granddaughter of Emile Loubet, a former president of the French Republic,[2] fills the canvas. She is palpably real and solid, and a calligraphic outline clearly distinguishes figure from ground. The soft pastel colors appropriate to the subject are enlivened by touches of deep crimson, orange, and green.

That Cassatt was successful is particularly remarkable in view of society's traditional reluctance to acknowledge women's professional competence. A staunch adherent of the feminist movement, she stood her ground against assertions of women's innate inferiority. It is telling that in answer to a disparaging comment made by Degas, suggesting that a woman had no right to criticize the style of a male artist, she painted a work so strong that the hypercritical Degas purchased it himself.[3]

Despite her expatriate status, Cassatt proudly identified with her homeland to the end of her life. Her work was exhibited, collected, and had a decisive impact in the United States, and the consistent realism of her painting is seen by many as quintessentially American. — *MHB*

[1] Susan Hobbs and Donald R. McClelland, "Mary Cassatt," in *Impressionistes Américains*, (Washington, D.C.: Smithsonian Institution Traveling Exhibition Service, 1980), 63.
[2] Adelyn Dohme Breeskin, *Mary Cassatt: A Catalogue Raisonné of the Oils, Pastels, Watercolors, and Drawings* (Washington, D.C.: Smithsonian Institution Press, 1970), 150.
[3] Nancy Mowll Matthews, *Mary Cassatt and Edgar Degas* (San Jose: San Jose Museum of Art, 1981), unpaginated.

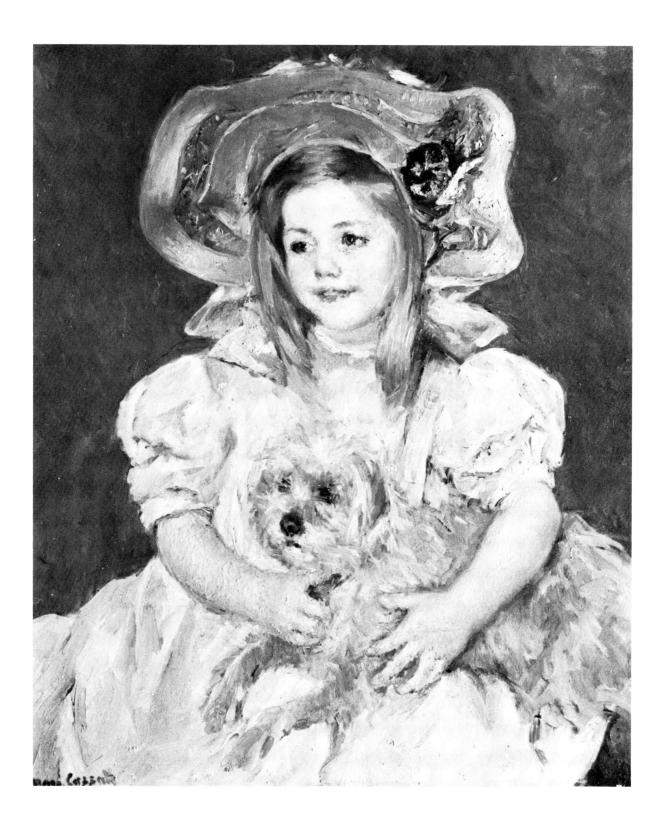

Theodore Robinson
1852–96

LA DÉBÂCLE (THE DEBACLE or
MARIE AT THE LITTLE BRIDGE),
1892
oil on canvas
18 x 22 in. (45.9 x 55.9 cm.)

Scripps College, Young
Collection, 1946

La Débâcle (Marie at the Little Bridge) has been described as one of the finest paintings that Theodore Robinson produced in France. In its subject, composition, color range, and brushwork it typifies Robinson's work of the period and indicates clearly both his debt to French Impressionism and his divergence from it.

Of the American painters attracted to Impressionism, Robinson was, aside from Cassatt, the most closely involved with it through his friendship with Pissarro and, more importantly, Monet. Robinson was not the first to seek out Monet, but from 1888, when he settled in Giverny next door to the French painter, he became an intimate and trusted friend. *La Débâcle* amply demonstrates this contact and influence. His paintings, included in an American Society of Artists exhibition in 1888, were among the first Impressionist-inspired works to be seen in this country. Along with Twachtman, Robinson was the most highly regarded of the American Impressionists.

There was, however, a limit to Robinson's adherence to the Impressionist aesthetic, and critics have long noted in his work a persistent concern for drawing and for structure that distinguishes his work from "classic" French Impressionism. In *La Débâcle*, Robinson's figures and architectural forms, while bathed in flickering, natural light, are never permitted to dissolve into it; they remain solid and substantial, as we know them to be. As William Gerdts points out, Robinson's realistic tendencies are also a reflection of his academic training in France.

Born in Vermont, Robinson studied art briefly in Chicago and New York. In 1876 he went to Paris, where he worked at the Académie Julian under the direction of two strict academicians: Carolus-Duran and Gérôme. His first contact with Impressionism probably occurred in 1877 when he spent the summer at Grez in the company of artists interested in *plein-air* painting. An excerpt from one of his diaries indicates his desire to balance academic concerns with what he was learning from Impressionism:

Although the possibilities are very great for the moderns, they must draw without ceasing... and with the brilliancy and light of real outdoors combine the austerity, the sobriety, that has always characterized good painting. [1]

La Débâcle, painted during Robinson's last summer in France, beautifully reconciles academic and Impressionist tendencies. The drawing is firm and sure, as is the composition, dominated by the strong diagonals characteristic of his work. The figure of Marie, his favorite model, is comfortably integrated into the scene while remaining distinct from the landscape, and the progression from foreground to background is convincing. As Gerdts comments, however, the high horizon line that Robinson preferred counteracts illusionistic recession into space, flattening the painting and reinforcing its two-dimensionality in a manner more similar to Cézanne than to Monet. The unassuming and anonymous figure, caught unawares in nature, and the specificity of season (*La Débâcle* refers to the break-up of the ice in spring)[2] are characteristically Impressionist, as are the color range and broken brush strokes that create a lively surface texture.

In 1892, the year he painted *La Débâcle*, Robinson went home to Vermont. Having spent a great part of his life in France, he determined to regain his sense of place; for the remaining four years of his life, he painted his native landscape. His late works, exhibited and for the most part favorably reviewed, continued to reflect the blending of academic and Impressionist sources so brilliantly accomplished in *La Débâcle*. —MHB

[1] From Robinson's unpublished diaries, Frick Art Reference Library, New York, quoted in William H. Gerdts, *American Impressionism* (Seattle: The Henry Art Gallery, University of Washington, 1980), 53.
[2] *La Débâcle* may also refer to Emile Zola's novel of the same name, which was published the year Robinson finished the painting.

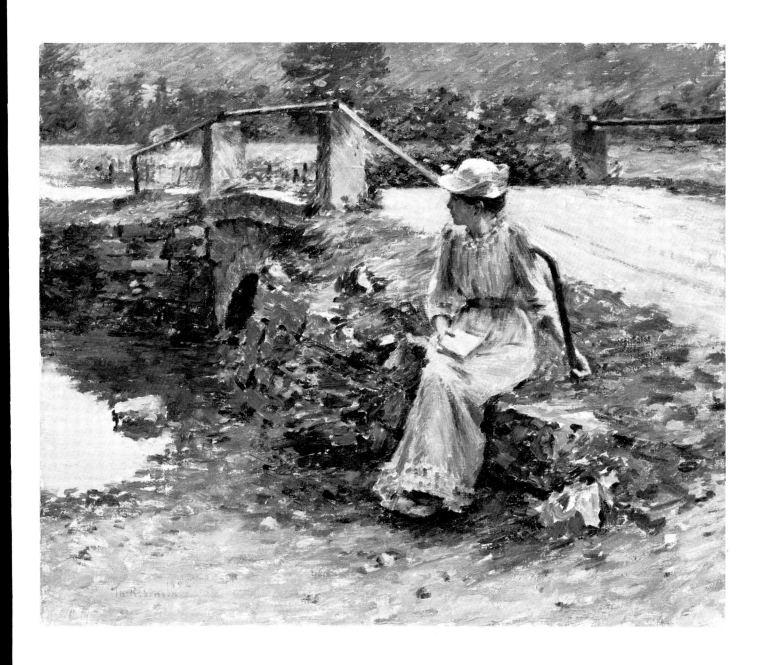

John Henry Twachtman
1853–1902

SNOWBOUND
oil on canvas
22 x 30 ⅛ in. (55.9 x 76.5 cm.)

Scripps College, Young
Collection, 1946

*I can see how necessary it is to live always in
the country—at all seasons of the year...
Nature is never more lovely than when it is
snowing. Everything is so quiet, and the
whole earth seems wrapped in a mantle...all
nature is hushed to silence.*[1]

John Henry Twachtman was, above all
else, a painter of nature. As evidenced in
his letter above and in numerous paint-
ings—of which *Snowbound* is a particularly
fine example—it was the winter landscape
that most attracted him. The appeal of nature
"wrapped in a mantle" of snow must surely
have been, in part, the opportunity it offered
the painter to deal with the subtleties of
white; in this analytical interest in optical
sensation Twachtman is properly associated
with Impressionism. The evocative character
of his paintings, however, communicates an
emotional responsiveness that distinguishes
his work from the more systematic manner
and emotional neutrality of his French con-
temporaries. Twachtman rarely traveled to
find subjects, preferring familiar landscapes;
Snowbound depicts the family home near
Greenwich, Connecticut, that he designed
and helped to build. A slightly different view
of the house is seen in a second painting, also
entitled *Snowbound* (fig. 4).

Twachtman was born and first studied art
in Cincinnati, a city he later referred to as "a
very foggied place (where) only one kind of
art is considered good, the old Dusseldorf
School."[2] From 1875–77 he worked with
Frank Duveneck in Munich and subsequently
taught in Cincinnati and New York. In 1883
Twachtman spent a year at the Académie
Julian in Paris along with Metcalf, Tarbell, and
Hassam. These four were to be instrumental
in the 1897 creation of the Ten American Art-
ists, a group that resigned from the Society of
American Artists in protest against its in-
creasingly large and conservative exhibitions.

Despite academic training, which stressed
figure drawing, Twachtman remained a
committed landscape painter. The lyricism of
his later work, characterized by thin washes
and subtle tonal relationships and by increas-
ingly flat, abstracted, and asymmetrical com-
position, reflected his contact with Whistler
and Japanese art. Robinson recalled in his
journal, years later, the hours that he and
Twachtman had spent examining Japanese
prints.[3] The two-dimensionality of *Snow-
bound*, its surface pattern accentuated by a
high horizon and dominated by the calli-
graphic diagonal of the receding wall, indicates
a relationship between the painting and
Japanese art. — *MHB*

[1] Letter from Twachtman to J. Alden Weir, quoted in
Gerdts, *American Impressionism*, 68.
[2] Gerdts, 67
[3] Richard J. Boyle, *American Impressionism* (Boston:
New York Graphic Society, 1974), 164–5.
[4] Hobbs and McClelland, "John Henry Twachtman," in
Impressionistes Américains, 138.

FIG. 4 John Henry Twachtman,
Snowbound, Montclair Art Museum,
Montclair, New Jersey, Museum
Purchase, 1951

STREET IN PONT-AVEN, BRITTANY,
1897
oil on canvas
25 x 30 in. (63.5 x 76.2 cm.)

Scripps College, Young
Collection, 1946

Frederick Childe Hassam produced a large and impressive body of work that met with critical acclaim both in this country and abroad. His success as an artist, his involvement with artists' colonies on the East Coast, and his leading role in the foundation of the Ten make him one of the major figures of American art of this period. Different as they are in subject and style, his three paintings in the Young Collection represent particularly well the range and brilliance of his later work.

Hassam was born in Dorchester, Massachusetts. Like many of his contemporaries, he trained first as a draftsman, designing works to be engraved for magazines and illustrated books. His conversion to painting, which he came to love above all else,[1] dates from his studies in the early 1880s in Boston.

Although he had traveled abroad briefly in 1883, it was during his second sojourn of 1886–89 that the effect of contemporary French art was first seen in his work. During this period he worked for a short time at the Académie Julian, as had Robinson, Tarbell, and Twachtman. Of French Impressionist painting he wrote: "I saw these experiments in pure color and understood that I would try to do them." Upon his return to America he proclaimed himself an Impressionist.[2]

The 1880s and 1890s were marked by critical success for Hassam. He exhibited in the Paris Salons of 1887 and 1888, winning a Gold Medal; at the Paris International Exposition of 1889; and at the World's Columbian Exposition held in Chicago in 1893.

In 1897 Hassam returned again to France. *Pont-Aven, Brittany*, which dates from this trip, depicts a street in the village where Paul Gauguin and Emile Bernard had worked a decade earlier. Hassam's urban view is dominated here by a deep and narrow perspective: the disappearing street is framed on both sides by buildings that fill the height of the canvas. The scene, half sunlit and half in shadow, offered the painter an opportunity to study the effect of changing light. This interest, along with the brilliant chromatic range of the painting and the tapestry-like surface of rough, broken brushstrokes, surely reflects Hassam's awareness of later Impressionist painting. —*contd.*

[1] Boyle, *American Impressionism*, 150.
[2] Hobbs and McClelland, "Childe Hassam," in *Impressionistes Américains*, 91.

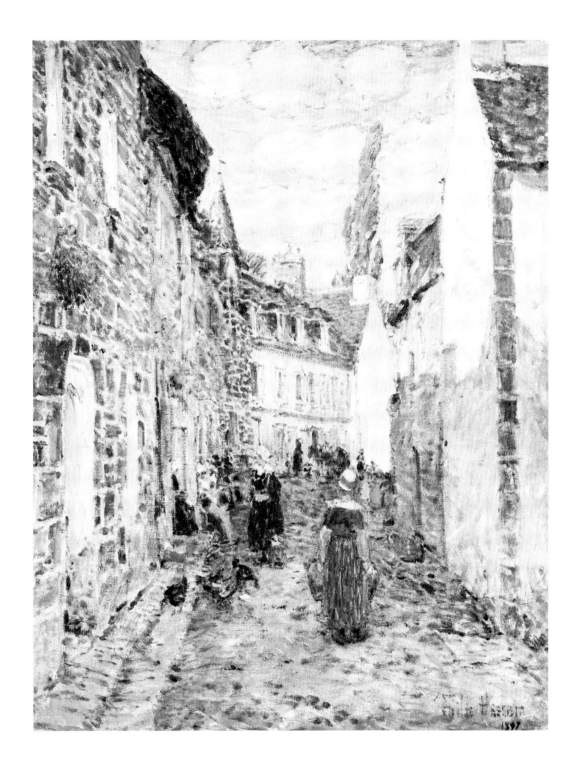

HIGHLAND LIGHT, 1900
oil on canvas
24⅛ x 22 in. (61.3 x 55.9 cm.)

Scripps College, Young
Collection, 1946

The impact of Impressionism is equally apparent in *Highland Light,* dated 1900. From the 1880s onward, Hassam spent summers painting along the Connecticut coast at Old Lyme and Cos Cob where there were active artists' colonies, and at Gloucester, Provincetown, Newport, and Appledore on the Isle of Shoals off the coast of New Hampshire. His panoramic views of the 1890s and early 1900s are considered by many to be the finest of his paintings. *Highland Light,* typically, uses topography to create solid structure within an asymmetrical and deceptively casual composition. Its brilliant color and luminosity, which evoke the feeling of ocean air on a sunny day, are purely Impressionist. The work invites comparison with Monet's views of the Normandy coast in the 1880s. —*contd.*

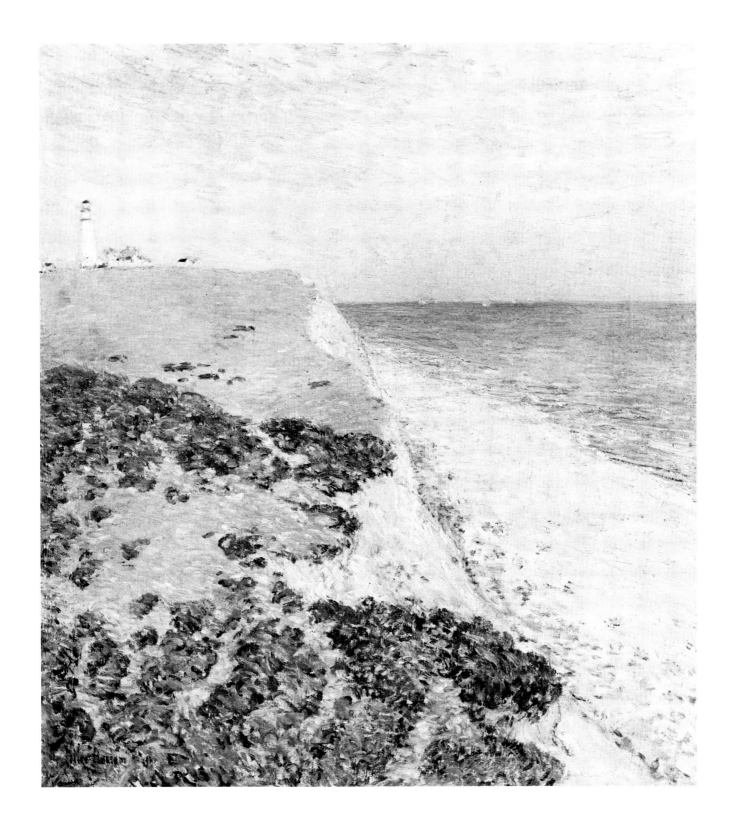

Frederick Childe Hassam
1859–1935

THE MODEL DISROBING, 1918
oil on canvas
24½ x 22¼ in. (61.3 x 56.5 cm.)

Scripps College, Young
Collection, 1946

After 1900 Hassam turned increasingly to painting nudes in both indoor and outdoor settings. In *The Model Disrobing*, the subject is seen from behind in a pose that appears both studied and casual. Characteristically for Hassam, the figure is simplified and clearly outlined against the background, in this case a close-cropped studio view. The dark palette, smooth brush, and almost academic character of this work provide an instructive contrast with the two earlier paintings. The three together, spanning a period of only eleven years, offer considerable insight into the *oeuvre* of Childe Hassam. —*MHB*

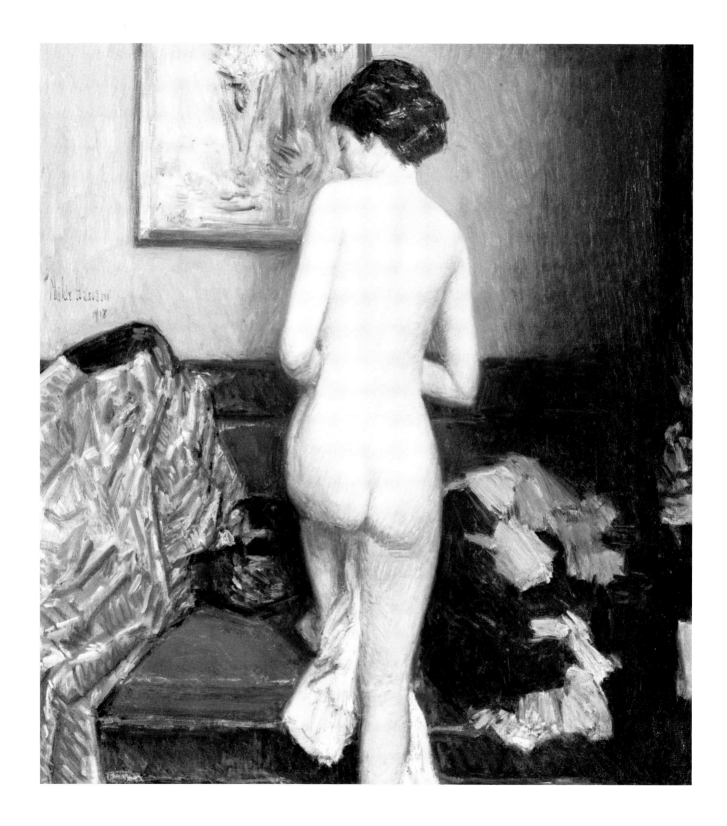

Edmund Charles Tarbell
1862–1938

THE VIOLINIST (or GIRL WITH A
VIOLIN), c. 1890
oil on canvas
24¼ x 20⅛ in. (61.6 x 51.1 cm.)

Scripps College, Young
Collection, 1946

Edmund Charles Tarbell became a student at the School of the Museum of Fine Arts, Boston, in 1879 after working as a lithographer. He left for Paris in the summer of 1884 and enrolled at the Académie Julian to study with Boulanger and Lefebvre and then with the American expatriate Dannat. Returning to Boston about 1886, he became an influential instructor at the School of the Museum of Fine Arts, where he taught from 1889 until 1913. Tarbell was one of the founding members of the Ten in 1897.[1]

The subject of *The Violinist* is an unidentified young woman who is probably a member of an upperclass Boston family. Her dress, with its low-cut bodice and tight corset extending below the waist, is in the style of evening gowns fashionable in the 1880s.

In effect the painting is similar to those of John Singer Sargent, another Boston society portraitist who was Tarbell's contemporary and to whom he can be compared. Tarbell, "who might be called the dean of American Impressionist portraitists," as Michael Quick suggests, achieves in his best portraits "a fluency and shimmering elegance worthy of Sargent."[2] In *The Violinist*, the extreme contrasts between light and dark and between sharp and blurred contours, as well as the slightly revealing evening gown, echo Sargent's 1887 portrait of Mrs. Charles Inches.[3]

Though Tarbell shows the young woman about to begin playing the violin—one hand rests on her knee holding the bow (reversed) and the other hand is in a chord position—she is not in action, but rather in contemplative repose. Her posture is typical of the idealized woman so common in late 19th-century art and often seen in American Impressionism (fig. 5). — *NSG*

[1] Bernice Kramer Leader, "The Boston School and Vermeer," *Arts Magazine*, 55 (*November 1980*): 176.
[2] Michael Quick, "Achieving the Nation's Imperial Destiny: 1870–1920," in *American Portraiture in the Grand Manner*, 71. cf. Patricia Jobe Pierce, *The Ten* (Concord, New Hampshire: Rumford Press, 1976), 121–124.
[3] Richard Ormond, *John Singer Sargent: Paintings, Drawings, Watercolors* (New York: Harper & Row, 1970), 243, pl. 50.

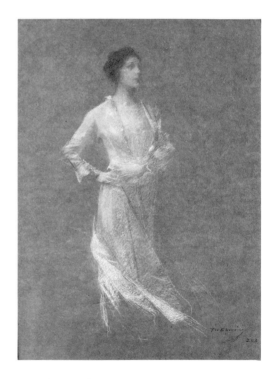

FIG. 5 Thomas Wilmer Dewing
(1851–1938), *Standing Figure*, pastel
on paper, Scripps College

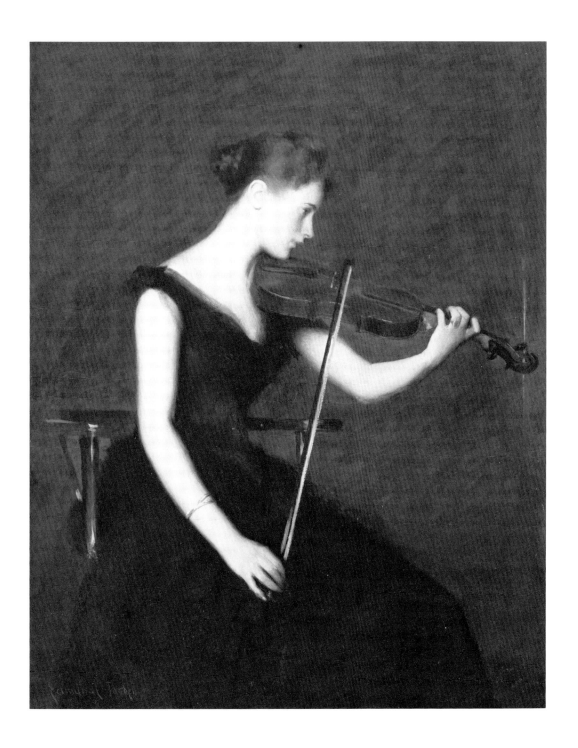

THE BOULEVARD, PARIS, C. 1900
oil on panel
10⅛ x 14 in. (25.7 x 35.6 cm.)

Scripps College, Young
Collection, 1946

Perhaps no American painter better exemplifies the transition from the 19th to the 20th centuries than Maurice Prendergast. *The Boulevard, Paris,* c.1900, is in many respects a painting of the former century; *Crépuscule,* c.1920, is, in spirit as well as date, of the latter.

Born in 1859, Prendergast was a self-taught artist. Like so many of his contemporaries, he worked first as a draftsman and illustrator. He was in his early thirties when he first saw Paris. He studied briefly at the Académie Julian in 1892, about the same time as Matisse, and at the Académie Colarossi in 1893. As Eleanor Green notes, this relatively late start may help to explain both Prendergast's responsiveness to the newest currents in European painting and his ability to accept and reject influences according to his own well-defined artistic needs, thus maintaining a vision that was always uniquely personal.[1]

The fact that Prendergast returned to Boston in 1895 a well-trained professional had less to do with the academies he had attended than it did with rigorous self-training. He had spent endless hours sketching the boulevards of Paris and had studied Impressionist, Post-Impressionist, and Nabi painting on view at Durand-Ruel's gallery. A preference for warm, summery scenes of people in movement, in city and country, and the small, comma-like strokes of color that suggest form without precisely defining it, remained central to Prendergast's aesthetic. His art was one of synthesis and transformation, directed toward "making the world more beautiful than it is."[2] Although called an Impressionist, he had less interest in analyzing and recording the optical phenomena of a given view than in creating through color a parallel world that, almost incidentally, referred to nature.

Prendergast excelled in watercolor, for which he was best known in the 1890s, and rejected the traditional academic hierarchy that ranked it beneath oil painting. *The Boulevard, Paris,* painted during his second European sojourn (1899–1900), shares much with his watercolors. The technique is loose and economical, the pigment brushed thinly over a bare panel. The grain of the panel is evident, particularly in the foreground and along the right side. The perspective of the scene is unclear, and the figures, barely suggested, are arranged according to the needs of color harmony and surface pattern rather than verisimilitude. One does not find here the specificity of time, place, and atmosphere associated with the Impressionist urban view; this aesthetic distance is typical of Prendergast.
—*contd.*

[1] Eleanor Green, *Maurice Prendergast* (College Park: The University of Maryland, 1976), 11.
[2] Ibid., 13.

*Maurice Brazil
Prendergast
1859–1924*

CRÉPUSCULE, C. 1920
oil on canvas
20¼ x 24¼ in. (51.4 x 61.6 cm.)

Scripps College, Young
Collection, 1946

Prendergast returned to America in 1900 to mount a series of well received exhibitions. He exhibited with the Eight, although his style and the bourgeois subjects he preferred were quite different from the Ashcan School's dark, heavily painted views of New York's lower-class life.

Crépuscule was painted late in Prendergast's career. A pastoral scene of bathers at the shore, it is a tightly packed mosaic of color with a heavily worked surface. This tendency toward abstraction of form and concern with surface pattern increasingly characterized Prendergast's work after a series of return trips to Europe between 1907 and 1914. *Crépuscule* reflects the influences of Cézanne, Vallotton, and Vuillard, along with that of Matisse, whose *Luxe I*, similar in its sinuous curves and spatial flattening, Prendergast had seen and copied. Ultimately, however, Prendergast's borrowings from contemporary European painting were so highly selective that comparisons with other artists have little meaning. Caught up in the "impulse for newness" of the early 20th century, his work, while reflecting avant-garde tendencies and concerns, remained unmistakably his, the product of a vision that was uniquely and consistently personal. —*MHB*

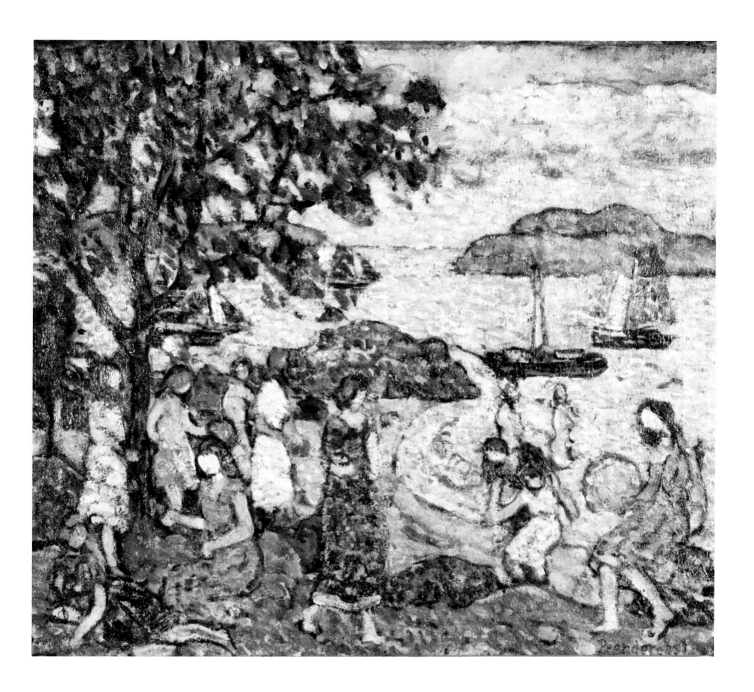

Julian Alden Weir
1852–1919

THE JANITOR'S DAUGHTER (or THE
GIRL IN WHITE), C. 1906–1910
oil on canvas
28 x 20¹/₁₆ in. (71.1 x 50.9 cm.)

Scripps College, Young
Collection, 1946

Julian Alden Weir and his elder brother Robert Ferguson Weir (later head of the Yale University Art School) had their first art instruction under their father, a professor of drawing at West Point. In the fall of 1873, after several years of study at the National Academy of Design in New York, the younger Weir left for Paris and enrolled at the École des Beaux Arts, entering the atelier of Gérôme and also studying briefly with other artists. Weir returned to New York in the autumn of 1877 and taught at the Cooper Union Women's Art School and the Art Students League. He was one of the founding members of the Ten in 1897. Although he had earlier stated an extreme distaste for Impressionism, calling the third Impressionist exhibition of 1877 in Paris "worse than a Chamber of Horrors,"[1] Weir was to become the "patriarchal figure among the American Impressionists"[2] after the mid-1880s.

His late figural paintings, beginning in the mid-1890s, are extremely textural; they have a thick surface layer of paint and often a striation of pigment from the artist's use of the wooden end of his brush. They demonstrate a "somewhat tonal, rather than chromatic, Impressionism, with the emphasis upon a limited palette of varied hues."[3] The dresses of his female sitters are "often white, toned down by the addition of gray or beige; the decorative elements, a soft pink or rose color; the backdrops, neutral and low-keyed colors."[4] Weir's late paintings are usually of "a single, half-length figure that is shown close up against a flat background, with relatively few accessories or props."[5]

These characteristics can be seen in the *Janitor's Daughter* (or *Girl in White*). Its painted surface is highly textural and the figure is set off against a darkish neutral background interrupted only by the back of a chair. The sitter's white dress is highlighted by yellow and her blond hair is partially tied with red ribbons, the color dabbed on gently so as not to detract from the overall neutral tonal effect.

The sitter was apparently the daughter of the superintendent of the Tenth Street Studio Building in New York.[6] Neither the father's nor the daughter's name is known.

The Studio Building was located at 51 West 10th Street with an annex at 55 West 10th. "Most of the tenants were painters, but several sculptors, writers, and architects rented space there as well," fulfilling Richard Morris Hunt's design for "a building exclusively devoted to adequate work and exhibition space for artists."[7] Weir's brother occupied space there from 1861 until 1872 and Weir had use of his studio while in New York during the early 1870s. Weir rented a studio there for himself in the summer of 1873 and again from 1906 until 1919.[8] — *NSG*

[1] Dorothy Weir Young, *The Life and Letters of J. Alden Weir* (New Haven: Yale University Press, 1960), 123.

[2] Gerdts, *American Impressionism*, 71.

[3] Ibid., 74.

[4] Doreen Bolger Burke, *J. Alden Weir, An American Impressionist* (Newark: University of Delaware Press, 1983), 243.

[5] Ibid.

[6] Dorothy Weir Young, "Records of the Paintings of J. Alden Weir," (unpublished MS) IIIA, 251: "The Janitor's Daughter. Young Girl in White. Painted in the studio in 10th St."; and letter of Frank Rehn to General Young, 23 January 1929: "[Mrs. J. Alden Weir] knew the picture well and that to the best of her remembrance the subject of it was the daughter of the superintendent of the 10th Street Studio." Unpublished collection notes of General and Mrs. Young, 1946, Scripps College.

[7] Annette Blaugrund, "The Tenth Street Studio Building: A Roster, 1857–1895," *American Art Journal* 14 (Spring 1982): 64.

[8] Ibid., 71; Burke, *J. Alden Weir*, 258, 298; personal letter from Annette Blaugrund to NSG, June 6, 1984.

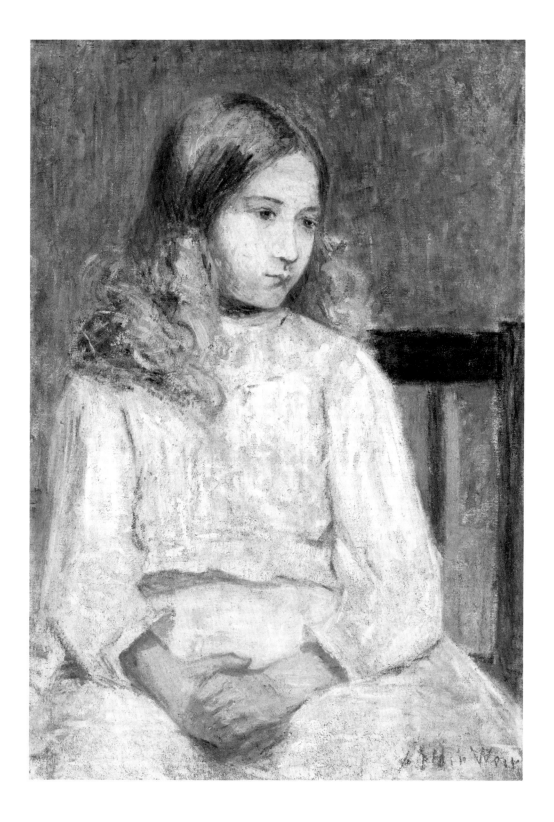

Willard Leroy Metcalf
1858–1925

THE APPROACHING FESTIVAL, 1922
oil on canvas
29 x 33¼ in. (73.5 x 84.4 cm.)

Scripps College, Young
Collection, 1946

A grandiose subject is not an assurance of a grandiose effect but, most likely, the opposite.—Wallace Stevens, "Adagio"[1]

Willard Leroy Metcalf, who spent much of his life painting the landscape of his native New England, was particularly known for his sensitive depictions of the four seasons. The *Approaching Festival*, 1922, its title referring to the coming of autumn and *October Sunshine*, 1923 (following), are autumnal scenes that typify Metcalf's mature style. Both give us pleasant, sunny views, quiet and uncomplicated, neither grandiose nor narrative. Both roughly square, a format Metcalf preferred, they are painted thinly, in small strokes of color, with areas of canvas left bare throughout. The resulting quality of sketchiness is not, however, achieved at the expense of clarity; individual landscape elements and their placement in space remain distinct, and the strength of Metcalf's draftsmanship is apparent.

Compositionally, the two works form an interesting contrast. *The Approaching Festival*, with its gentle topography extending virtually uninterrupted to the frame on all sides, downplays design on the part of the artist. *October Sunshine* is, on the other hand, more formally controlled. The hill on which we stand is defined by an undulating outline and framed by the strong verticals of the trees. We look across a valley, foreshortened by a deliberate blurring of details, to a responding hill and the mountains beyond. Metcalf's palette reinforces this layering of space, alternating as it does between yellow-green and blue-violet with complementary areas of brilliant orange. The result is a visual linking of planes through design and color that offers both a strong and cohesive composition and a comfortably illusionistic view.

Born in Lowell, Massachusetts, Metcalf spent much of his childhood in Maine. He studied in Boston and as a young man summered in the White Mountains of New Hampshire, frequently inscribing his paintings "after nature" to make clear his belief in the necessity of working *en plein air*. He also traveled to France, where he worked at the Académie Julian and painted in Brittany and at Giverny. Like Robinson and others, Metcalf sought out Monet; although his use of color reflects this contact, his subjects remained closer in spirit to the work of the Barbizon painters. Involved with the Ten, upon whose members he had considerable influence, Metcalf exhibited his work to popular acclaim beginning in 1905.

In 1903 Metcalf withdrew to relative isolation in Maine in order to dedicate himself to the "uncomplicated and joyous interpretation of nature."[2] It was the work of this period, to which the two Scripps paintings belong, that earned him the admiring title "poet laureate of the New England Hills."[3]—*MHB*

[1] Elizabeth de Veer, *Willard Leroy Metcalf* (Springfield, Massachusetts: Museum of Fine Arts, 1976), unpaginated.
[2] Gerdts, *American Impressionism*, 79.
[3] Boyle, *American Impressionism*, 171.

Willard Leroy Metcalf
1858–1925

OCTOBER SUNSHINE, 1923
oil on canvas
24¼ x 24¼ in. (61.5 x 61.5 cm.)

Scripps College, Young
Collection, 1946

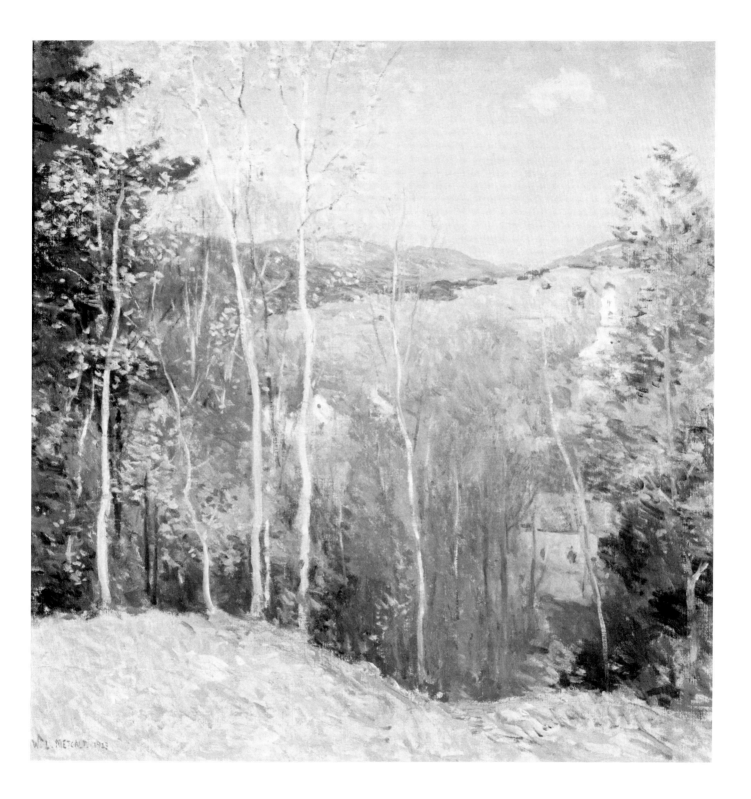

Other American Impressionists and Tonalism

Abbott Handerson Thayer
1849–1921

LITTLE GIRL WITH FLOWERS,
c. 1885–90
oil on canvas
18⅛ x 14 in. (46.0 x 35.6 cm.)

Scripps College, Young
Collection, 1946

Abbott H. Thayer's first art instruction was in his hometown of Boston under the amateur animal painter Henry D. Morse. His family's move to Brooklyn, New York, in 1867 enabled Thayer to study at the Brooklyn Art School and the National Academy of Design from 1868–1874. In 1875 Thayer went to Paris and enrolled at the École des Beaux Arts, where he studied with the highly influential and popular teacher Gérôme. He returned to New York in 1879 and then lived permanently after 1892 in Dublin, New Hampshire.

Little Girl With Flowers was probably painted during the last half of the 1880s. During this decade Thayer began a series of works on women and children as well as portraits of his family.[1] The sitter in this painting remains unidentified. Thayer also began another series of paintings in the late 1880s of a still life motif—a vase of roses.[2] *Little Girl With Flowers* incorporates both of these artistic interests. Also typical of Thayer's work in this period is his concern with the depiction of costume, especially its materials and textures; an expressive handling of paint, applied with broad brush strokes; and bold coloration.[3]

In the following decade, a dramatic alteration in style and iconographic interests occurred in Thayer's *oeuvre* as he concentrated on creating a more finished surface and on such themes as the idealized woman, the scientific depiction of animals, and landscape. —*NSG*

[1] Nelson C. White, *Abbott H. Thayer, Painter and Naturalist* (Hartford: Connecticut Printers, 1951), 42; Ross Anderson, *Abbott Handerson Thayer* (Syracuse: Everson Museum, 1972), 19.
[2] Anderson, *Abbott Handerson Thayer*, 93.
[3] White, *Abbott H. Thayer*, 214.

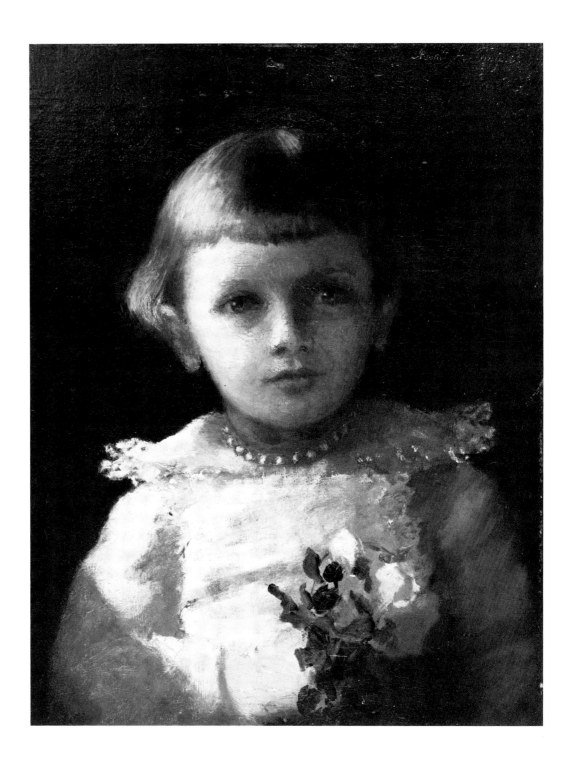

John Joseph Enneking
1841–1916

DUXBURY CLAM DIGGER, 1892
oil on canvas
22½ x 30½ in. (57.2 x 77.3 cm.)

Scripps College Collection

Primarily self-trained, John Joseph Enneking was already a successful artist in Boston before he went to Europe in 1872. He studied in Munich and in Paris, where he became a friend of the Barbizon painters Daubigny, Corot, and Millet. Enneking may have painted with Monet and Renoir. He also traveled in Italy, where the colorist Monticelli influenced his work. At the time Enneking returned to the United States in 1876, he was one of the first American artists to be painting in the Impressionist style.[1] It has been suggested that he was invited to join the Ten, but declined[2] because he did not wish to be identified with one group.

Enneking's style reflects a period of transition between the decline of Barbizon influence and the rise of American Impressionism. Too young to have been a part of the Hudson River School, but oriented toward realism, Enneking absorbed the Barbizon outlook from Charles Daubigny and its American version from Inness. Exposed early to Impressionism, he only partially adopted its techniques.

Working directly from nature, Enneking was adept at capturing the light and feeling of the changing day. He became known for his accurate, sensitive depictions of small corners of the natural world—forest interiors, fish ponds, November twilights, spring landscapes, New England settings. His most successful paintings are often Tonalist in feeling.

Duxbury Clam Digger shows a clam-digger at work on Cape Cod Bay, southeast of Boston. Another version shows the same subject—the model was the artist's father-in-law—from a different, more distant vantage point (fig. 6). The freshness and brilliance of the colors suggests spring or early summer, while the shadows indicate strong directional light. The brushwork is free and generous; the color is applied directly and layered to give depth and movement to the waving marsh grass. The figures are solidly rendered with impasto that catches and reflects the light.

Duxbury Clam Digger is one of at least six paintings Enneking sold at the Chicago World's Columbian Exposition in 1893. In comparing Enneking with the French and American Impressionists who also exhibited at the Exposition, Hamlin Garland commented:

> As I write this, I have just come in from a bee-hunt over Wisconsin hills, amid splendors which would make Monet seem low-keyed. Only Enneking and some few others of the American artists, and some of the Norwegians have touched the degree of brilliancy which was in the world today.[3] —MML

[1] Patricia Jobe Pierce and Rolf H. Kristiansen, *John Joseh Enneking: American Impressionist Painter* (North Abington, Massachusetts: Pierce Galleries, 1972), 31.
[2] *John J. Enneking: American Impressionist* (Brockton, Massachusetts: Brockton Art Center–Fuller Memorial, 1974), 8, 23.
[3] Hamlin Garland, *Crumbling Idols* (1894; reprint, Gainesville, Florida: Scholars Facsimiles and Reprints, 1952), 130.

FIG. 6 John Joseph Enneking, *Clam Digger in Duxbury, Massachusetts*, 1892, oil on canvas, Collection of Mr. and Mrs. Abbot W. Vose, Boston

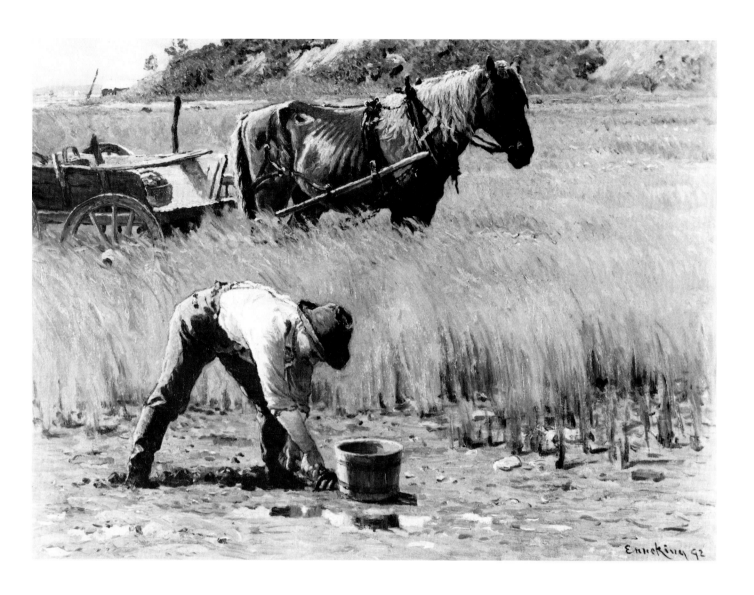

Alexander Helwig Wyant
1836–92

PASTURE HILLS, C. 1890
oil on canvas
20⅛ x 30³⁄₁₆ in. (51.1 x 76.6 cm.)

Scripps College, Young
Collection, 1946

The art of Alexander Helwig Wyant, although popular in the years immediately following his death in 1892, has been virtually ignored since the 1920s. The current interest in late 19th-century American painting has resulted in a re-evaluation of Wyant as an important Tonalist painter who can be compared with Inness. Both artists combine Barbizon sensibility with an individual vision in their later landscapes.

Like many of his contemporaries, Wyant received his early training as an artisan; his first job was sign-painting in his native Ohio. In 1858, inspired by the paintings of Inness in a Cincinnati exhibition, he traveled to meet the artist in New York. Inness subsequently became his lifelong mentor. During the 1860s Wyant studied in New York and Cincinnati, working both in oils and in watercolor. In 1867 he traveled in England and Ireland. *Blue Hills* (fig. 7) was inspired by his memories of the Irish countryside; it echoes the style and subject of his large oil *View in County Kerry, Ireland.*[1]

By 1870 Wyant's detailed Hudson River School approach was developing into a more lyrical style characterized by soft shadows, rounded contours, and heavy impasto. His work in watercolor, which remained an important part of his *oeuvre*, was perhaps an influence in this development.

Upon his return in 1874 from a painting trip in the West, Wyant suffered a stroke that paralyzed his right hand. He learned to work with his left hand, producing smaller and more intimate views of nature. *Pasture Hills*, c. 1890, was painted at Arkville in the Catskills, the artist's home for the last three years of his life.[2] By this time Wyant's right side was completely paralyzed, and the painting, done from memory, suggests a profound melancholy in its sense of transience. —*KK*

[1] Robert S. Olpin, *Alexander Helwig Wyant 1836–1892* (Salt Lake City: Utah Museum of Fine Arts, University of Utah, 1968), unpaginated.
[2] Unpublished collection notes of General and Mrs. E. C. Young, 1946, Scripps College.

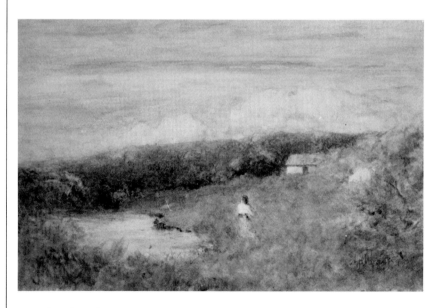

FIG. 7 Alexander Helwig Wyant, *Blue Hills*, watercolor on paper, Scripps College, Young Collection

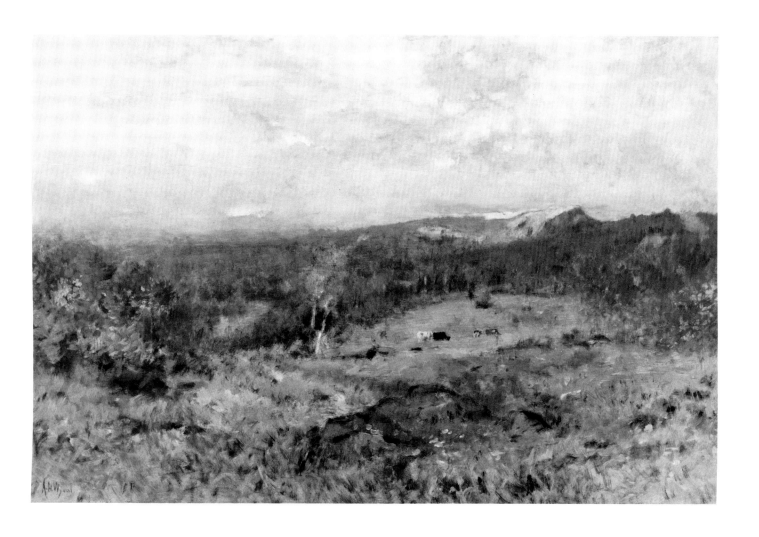

John Francis Murphy
1853–1921

LATE SEPTEMBER, 1907
oil on canvas
16¼ x 22¼ in. (41.3 x 56.5 cm.)

Scripps College, Young
Collection, 1946

J. Francis Murphy excelled in the poetic
and lyrical interpretation of the most
humble aspects of nature. Originally
a Chicago sign painter, Murphy was self-
taught. He moved to New York in 1875,
became a member of the Salmagundi Club,
and exhibited at the National Academy of
Design. His mature work was heavily in-
fluenced by Inness and by Wyant, who was
his summer neighbor in the Catskills.

Murphy's painting can be divided into
three periods, overlapping but fairly distinct
in style and orientation.[1] The early period, to
about 1885, was reminiscent of the Hudson
River School in its emphasis on the precise
reproduction of details from nature. The sec-
ond period, which lasted to about 1900, was
increasingly romantic, influenced by the
Barbizon aesthetic and Tonalism. The work
is small and intimate, with free brushwork,
suppression of detail, controlled light, and a
limited palette of subtle earth colors.

During the final period, 1901–16, Murphy
developed a style based on the Tonalist aes-
thetic and on his earlier work. The barren and
deserted fields of late fall are his primary
subject matter, as in *Autumn* (fig. 8). Form
and composition are extremely simplified,
and detail is merely suggested by the texture
of the brushwork. Most importantly, color
is limited to a narrow range of tones that
results in an all-enveloping golden vaporous
atmosphere.

Late September is remarkable for the won-
derful haze of color Murphy uses to depict
the autumn foliage and for the suffusion of
golden light filling the canvas. Despite its
ephemeral quality, there is a solidity to the
ground—the result of extensive underpaint-
ing—that is characteristic of Murphy, who
always maintains an equilibrium between
realism and romanticism.

It has been said that Murphy portrays in
landscape the elementary human response to
nature. His realism, simplicity, sincerity, and
eloquence explain his immense popularity
during his lifetime:

From the onset of his career, the simple,
poetic beauty of his canvases won him
unstinted admiration, and it is no small
tribute to the taste of the art-loving
public that pictures so devoid of show
and mere brilliance, so shorn of con-
ventional treatment or mere prettiness
or picturesqueness, so unpretentious,
should have found favor readily with
jurors and purchasers.[2] —*MML*

[1] Eliot Clark, *J. Francis Murphy* (New York: Privately
printed, 1926), 22.
[2] Harold T. Lawrence, "J. Francis Murphy, American
Landscape-Painter," *Brush and Pencil* 10, no. 4 (July
1902): 213.

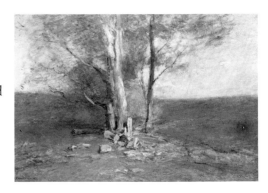

FIG. 8 J. Francis Murphy, *Autumn*, c.
1905–12, oil on canvas, Scripps College,
Young Collection

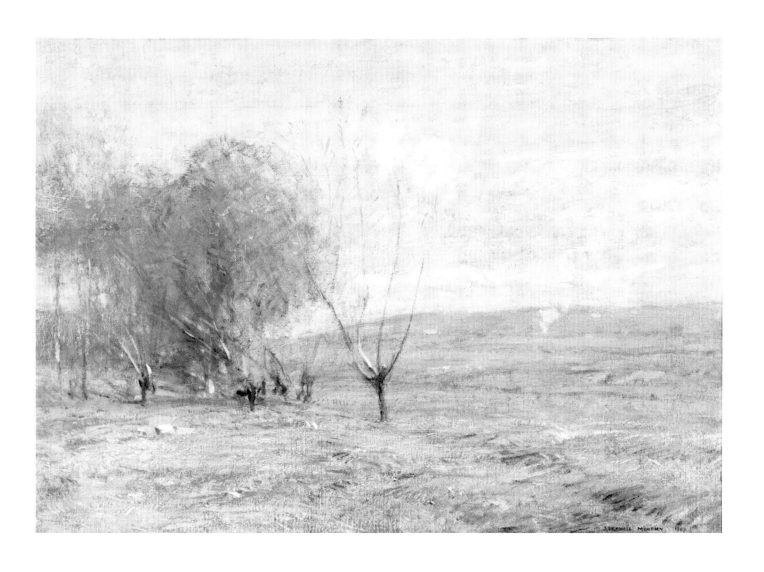

Charles Field Haseltine
1840–1915

A SUMMER DAY, 1905
oil on canvas
20⅜ x 26⅝ in. (51.7 x 67.5 cm.)

Scripps College, Gift of Mr. and
Mrs. Stephen I. Zetterberg, 1975

Born in Philadelphia, Charles Field Haseltine was a younger brother of the landscape and marine painter William Stanley Haseltine and the sculptor James Henry Haseltine. Little is known about his working life as an artist, other than that he generally painted landscapes. He was also an art dealer, and he established the Haseltine Art Galleries in Philadelphia.[1] Few of his works are in public collections. Only three (including *A Summer Day*) are currently documented by the Archives of American Art.

A Summer Day is a pastoral landscape that is Tonalist in feeling, remarkably similar in composition to works by Murphy and Inness. There is a prominent horizon line broken by a row of trees on one side, a reflecting body of water in the foreground, and a view to the distance with a farm building on the horizon. Detail has been eliminated in favor of generalized representation of forms. The painting has a greenish-gold cast, the result of the intense yellow-green of the grass and golden-brown foliage of the trees, both of which are reflected in the marsh water of the foreground. The canvas is finely finished with little evidence of brushwork. The grazing cattle are an anomaly, as the typical Tonalist landscape is usually characterized by abandoned fields. —*MML*

[1] George C. Groce and David H. Wallace, eds., *The New York Historical Society Dictionary of Artists in America, 1564–1860* (New Haven and London: Yale University Press, 1957), 298.

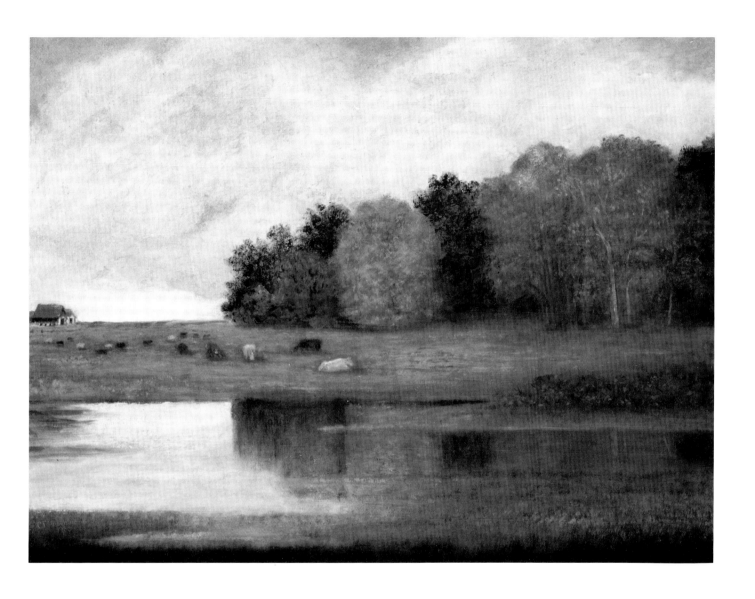

Soren Emil Carlsen
1853–1932

NIAGARA RIVER AND GOATS
ISLAND
oil on canvas
14⅞ x 17⅞ in. (37.6 x 45.6 cm.)

Scripps College,
Gift of Mrs. Henry Everett

Soren Emil Carlsen was a self-taught artist who, while friends with many of the leading American Impressionists, developed a unique personal *oeuvre*. Born in Denmark into a family of artists, Carlsen studied briefly with his cousin before emigrating to the United States in 1872. Although he started his career as an architectural assistant, his subsequent decision to become a painter was confirmed during a visit to Paris in 1875. His exposure to the work of Chardin led to his concentration in still life painting.

In later years Carlsen concentrated more on landscapes and seascapes. He did a number of studies of the Niagara Falls area,[1] of which *Niagara River and Goats Island* is one. Its small size, square format, and limited viewpoint is typical. The Impressionist-inspired colors are soft, in limited tints of blue and green, and there is the familiar Tonalist effect of an atmospheric haze rising from the river. As with Carlsen's other landscapes and his still lifes, the viewer recognizes the realism of his portrayal and yet senses something of a controlled sentiment for the beauty of nature:

> No one was a better draughtsman with the power to see the thing as it really was, and lay its spirit in color before you in his own peculiarly emphasized manner, with a refinement that surprised you by its simplicity.[2]

Carlsen's bent towards simplicity is pronounced in *Niagara River,* which approaches abstraction. This abstraction is enhanced by his renowned attention to the refinement of the surface texture of his paint.

Contemporary critics felt that Carlsen's view of nature and his artistic aims went beyond decorative lyricism to mysticism. Indeed, the collector Duncan Phillips wrote of him:

> I know that Carlsen's only philosophic intention is to paint beautiful pictures. And yet it always seems to me that he is trying to find a formal symbolical expression for the thought that nature exerts at times an influence curiously hypnotic.[3] —*MML*

[1] *The Art of Emil Carlsen, 1853–1932* (San Francisco: Rubicon-Wortsman Rowe, 1975), 25.
[2] F. Newlin Price, "Emil Carlsen—Painter, Teacher," *International Studio* 75 (July 1922), reprinted in Ibid., 53.
[3] Duncan Phillips, "Emil Carlsen," *International Studio* 61 (June 1917), reprinted in Ibid., 67.

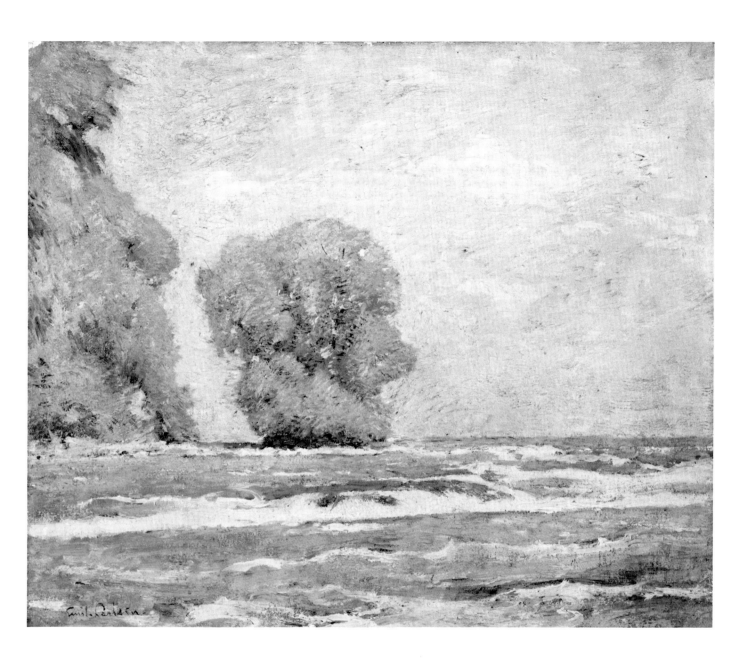

Walter Elmer Schofield
1867–1944

SUN AFTER RAIN
oil on canvas
20¼ x 24⅛ in. (51.0 x 61.0 cm.)

Scripps College, Young
Collection, 1946

Walter Elmer Schofield, often associated with Garber, was born in Philadelphia and studied at the Pennsylvania Academy of Fine Arts.[1] He spent time in Europe, studying at the Académie Julian in Paris and traveling to England, where he was especially taken by the southern coast. He joined the artists' colony at St. Ives, Cornwall, married an Englishwoman in 1897, and thereafter divided his time between England and the United States.

Despite his expatriate status and European training, Schofield became linked with the Pennsylvania landscape school, which was quintessentially American in style and orientation. Using Impressionist techniques, painting out-of-doors, and employing pure colors applied directly and lavishly, its artists produced large canvases depicting wide expanses of a countryside characteristically American in its ruggedness. As did most American Impressionists, they retained a significant degree of realism by depicting substance and solidity. The resulting straightforward quality and dynamism led critics to tout these artists as practitioners of American virility in landscape painting in the tradition of Winslow Homer.[2]

Although primarily known for his rural winter and water landscapes of the northeastern United States, Schofield painted many scenes of English seaside villages. *Sun After Rain* depicts Felixstowe in Suffolk. The Impressionist influence is evident in the construction of the picture plane through the aggregation of color masses. Detail is subordinated; viewed closely, the scene dissolves into a patchwork of color. The painting is atypically small for Schofield, but he has employed a strong diagonal composition to give great depth and distance, leading the eye quickly from the foreground of the village to the water beyond. Strong sunlight from the right rear of the picture plane creates shadow and blurred detail in the foreground.

In *Sun After Rain* Schofield captures the mood of place and time through the effects of changing weather and the sun's movement. This feeling for mood is a hallmark of his art.[3] —*MML*

[1] Gerdts, *American Impressionism,* 101.
[2] C. Lewis Hind, "An American Landscape Painter: W. Elmer Schofield," *International Studio* 48, no. 192 (Feb. 1913): 282.
[3] Eugen Neuhaus, *The History and Ideals of American Art* (Stanford: Stanford University Press, 1931), 283.

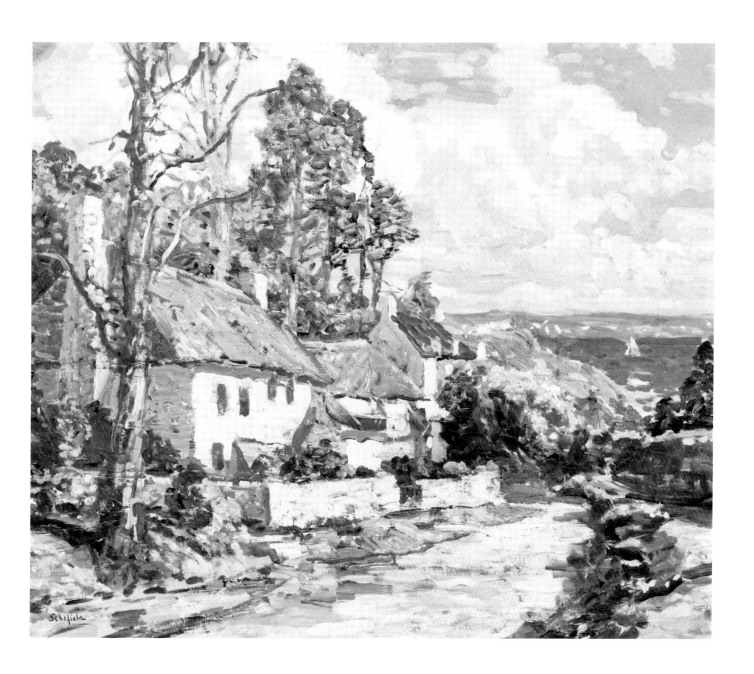

(George) Gardner
Symons
1863–1930

WINTER
oil on canvas
20¼ x 25 in. (51.3 x 63.5 cm.)

Scripps College, Young
Collection, 1946

George Gardner Symons, although born in Chicago and trained at the Chicago Art Institute, was often compared to Edward Redfield, Schofield, and others associated with the Pennsylvania landscape school because of his style and subject matter. Symons excelled in expansive depictions of the New England winter landscape.

Symons, considered a more poetic interpreter than the artists of the Pennsylvania school, was also more a master of the subtleties of composition and the decorative effect of the lines and patterns found in nature.[1] His work evolved over time from realism towards subjectivity:

His later work shows a sympathetic and more poetic interpretation of the subject, in which the painter does not rely so much upon the immediate reaction of the moment, but brings together his impressions in a more universal whole.[2]

Winter is an example of Symons's most typical subject, treatment, and composition. Forming a series of receding planes, the snow-covered hills slope inward from the edges to the center of the canvas, resulting in a complementary and rhythmic sequence from foreground to background, providing the illusion of deep space. The diagonal arc of the river coming from around the hill reinforces the feeling of distance and rhythm.

Symons makes generous use of color. The rich tints of green, blue and violet give depth and vibrancy and are especially effective in the underpainted areas of shadowed snow. The river, on the verge of freezing, is a deep glassy blue. The rim of the horizon is suffused with the pale mauve glow of a late winter afternoon as the sun disappears. *Winter* shows Symons at his best and most eloquent. —*MML*

[1] Neuhaus, *History and Ideals of American Art,* 283.
[2] Eliot Clark, "American Painters of Winter Landscape," *Scribner's Magazine* 72, no. 6 (Dec. 1922): 767.

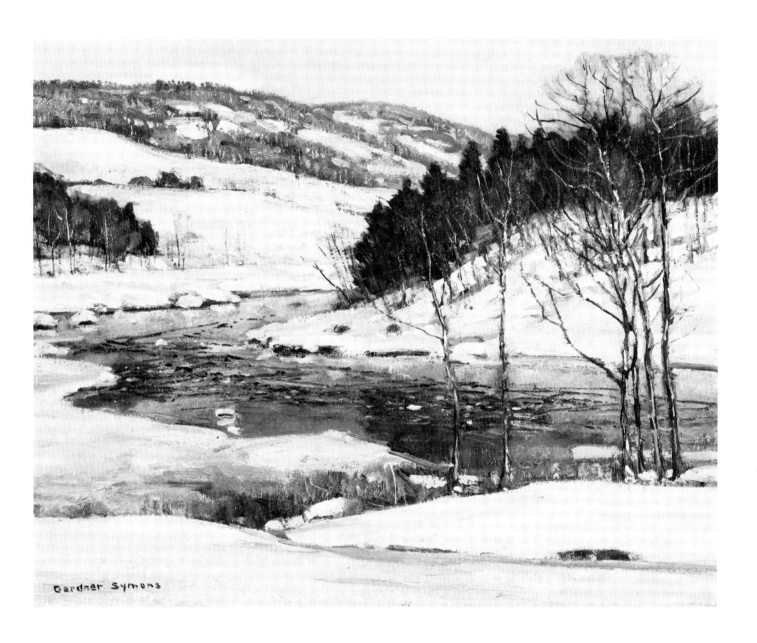

Gardner Symons

Daniel Garber
1880–1958

DOWN THE RIVER (or QUARRY),
1917
oil on canvas
25¼ x 30¼ in. (64.3 x 76.9 cm.)

Scripps College, Young
Collection, 1946

Daniel Garber is best known for a series of paintings of the quarries at Byram, New Jersey, seen from Limeport, Pennsylvania, across the Delaware River. *Down the River* belongs to this series as does *The Quarry* (fig. 9), both painted the same year. The monumental and carefully detailed rock cliffs that dominate the latter composition are, in *Down the River*, seen from a considerable distance, their sunlit faces depicted in a few painterly strokes of yellow ochre. *Down the River* exemplifies the quiet lyricism of Garber's serene and uneventful landscapes in its combination of closely observed detail, solid compositional structure, and skillfully rendered effects of light.

Garber was born on a farm in Indiana, the son of a Mennonite family of Pennsylvania-German extraction. Although not a church-goer as his family would have wished, he retained a "fundamental faith inspired by the study of nature."[1] He was associated with two of the most prestigious art academies of his day: Cincinnati, where Duveneck's influence predominated, and the Pennsylvania Academy of the Fine Arts, where he studied with Eakins and with Weir, who became his hero. He traveled in 1905 to England, Italy, and France, and he exhibited twice at the Paris Salon. Impressionism had a decided impact upon his work, although he was unmoved by more contemporary developments such as Fauvism:

> I want to paint things as I see them, and I don't see in blotches...I have too much respect for the trees and their true forms to make something out of them that I do not feel exists in them.[2]

In 1907 Garber returned to Pennsylvania to paint his native landscape. He remained there for the rest of his life, dividing his time between Philadelphia, where he taught at the Academy, and his home at Lumberville. He was a popular teacher and was considered the leader of the "Buck's County Group," Pennsylvania painters described in 1915 by Guy Pène duBois as the "democrats" of American art, in contrast to Boston's "aristocrats."[3] His style, "exactly the right mix of technical competence, stylistic progressiveness, and sheer beauty,"[4] won him critical and popular success. —*MHB*

[1] Kathleen A. Foster, *Daniel Garber* (Philadelphia: The Pennsylvania Academy of the Fine Arts, 1980), 17.
[2] Ibid., 25.
[3] Gerdts, *American Impressionism*, 98.
[4] Foster, *Daniel Garber*, 25.

FIG 9 Daniel Garber, *The Quarry (Across the Delaware from Limeport, Pennsylvania)*, 1917, oil on canvas, The Pennsylvania Academy of the Fine Arts, Philadelphia, Temple Fund Purchase, 1918

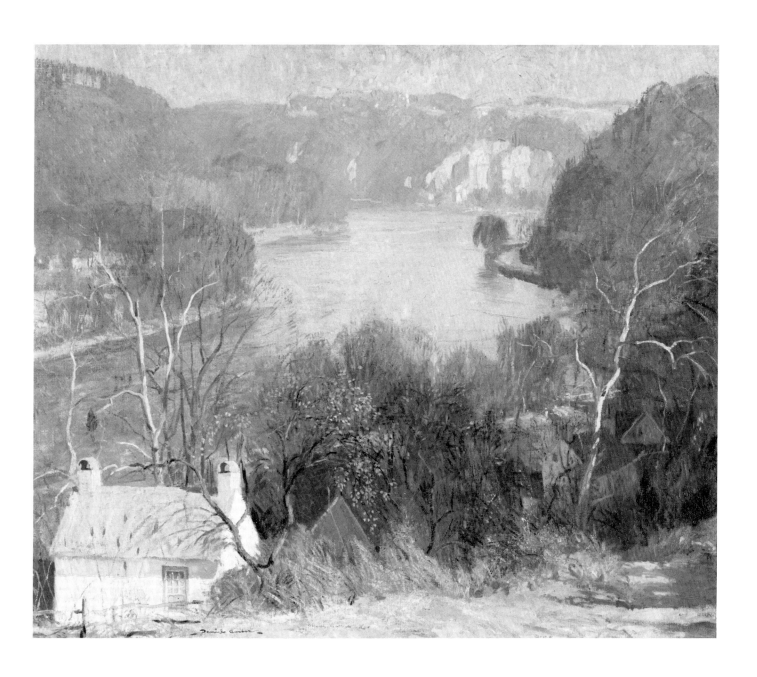

Gifford Beal
1879–1956

OLD TOWN TERRACE, 1914
oil on canvas
36¼ x 48½ in. (92.0 x 123.0 cm.)

Scripps College,
Gift of Millard Sheets, 1965

A native of New York City, Gifford Reynolds Beal was a precocious artist who began his studies at the age of twelve with William Merritt Chase at the Art Students League. His long association with the league included serving as its president from 1918–30.

Beal's subjects varied greatly. He excelled in the Impressionist-inspired portrayal of gardens, seascapes, circuses, and the Hudson River, but he is best known for his glimpses of the New York streets. His renderings are usually straightforward and unsentimental but still evocative of the tone of American urban life. Because of this he is often allied with the realists of the Ashcan School, although his viewpoint is more optimistic. Several of Beal's works were included in the Armory Show of 1913, and his art was praised in the 1920s for its indigenous character:

> Beal is a thoroughly American painter.
> As a pupil of Chase and Ranger, his
> student days were spent entirely in
> this country. His subjects are American,
> and it is not indulging in mere verbiage
> to say that in spirit his art is completely
> American.[1]

Beal used rich and brilliant colors to model his forms, which are usually depicted in strong light. This use of color and light is evident in *Old Town Terrace*, with its layering of light greens and yellows on dark green to indicate the direction of sunlight, the mass of trees, and the deep slope of the hill. The brushwork is free, spontaneous, and gestural, especially in the figures. The composition is dynamic; the crossing diagonals of the sunlight and pathways set up tension and lead the eye deep into the picture plane. Beal effectively uses the differing scale of the foreground and background to reinforce the feeling of depth.

The setting of *Old Town Terrace* is near Newburgh, New York, on the Hudson River. Another version of the scene, in a private collection, shows the view from the top of the hill in the opposite direction, out across the river. It can be said of *Old Town Terrace*, as with most of Beal's art:

> His statements are generally blunt, direct,
> one reads few things between his lines.
> But the principal one of these is charm; a
> charm that is never calloused by constant
> contact with nature nor dissipated by the
> theoretical sophistications of the
> trickster.[2] —*MML*

[1] Helen Comstock, "Gifford Beal's Versatility," *International Studio* 77, no. 313 (June 1923): 237.
[2] Guy Pene du Bois, *Paintings and Watercolors by Gifford Beal* (New York: Kraushaar Galleries, 1923), excerpted in *A Centennial Exhibition: Gifford Beal 1879–1956* (New York: Kraushaar Galleries, 1979), unpaginated.

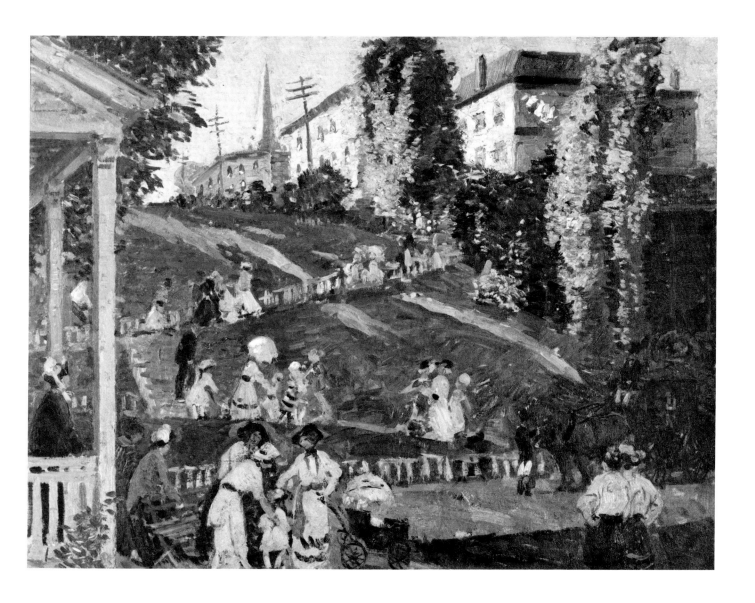

(Robert) Bruce Crane
1857–1937

GREY MANTLE, 1924
oil on canvas
18 x 24 in. (45.7 x 60.9 cm.)

Scripps College, Young
Collection, 1946

The art of Bruce Crane represents the continuance of the Tonalist landscape tradition that began with Inness. Crane, who was born in New York, studied with Wyant and traveled in France, where he came under the influence of the Barbizon painter Jean Charles Cazin.

Crane's personal style was well articulated by 1900. His landscapes, exemplified by *Autumn* (fig. 10), are dominated by the golden, hazy tones of fall and usually consist of the simple elements of a meadow, a narrow stream, and a few trees. In the Barbizon style, details of nature are recorded; however, there is an overall misty Tonalist atmosphere that points to the artist's imagination. "The object of studying and sketching out of doors is to fill the memory with facts," Crane said, and he seldom used his landscape sketches while painting.[1]

Crane's later work, including *Grey Mantle*, shows his interest in Impressionism, espe-cially as it was formulated in the snow scenes of his friend Twachtman. *Grey Mantle* is characterized by the short, broken brush-strokes and multi-toned colors of the Impres-sionists. It is not, however, an exact scientific exploration of the effects of light, but rather a rendering of mood.[2]

Often compared to the art of his contempo-rary and admirer Murphy, Bruce Crane's conservative landscapes faded in reputation soon after his death. —*KK*

[1] Harold T. Lawrence, "A Painter of Idylls—Bruce Crane," *Brush and Pencil* 1 (Oct. 1902):8, 9; quoted in Charles Teaze Clark, "Bruce Crane, Tonalist Painter," *Antiques* 122 (Nov. 1982): 1062.
[2] Beginning in 1904, Crane summered at the artists' colony of Old Lyme, Connecticut, which was a center of American Impressionism. See Jeffrey W. Anderson, "The Art Colony at Old Lyme," in *Connecticut and American Impressionism* (Storrs: William Benton Museum of Art, University of Connecticut, 1980), 114–149.

FIG. 10 Bruce Crane, *Autumn*, c. 1915,
oil on canvas, Scripps College, Young
Collection

Dwight William Tryon
1849–1921

EVENING, 1920
oil on wood panel
8⅞ x 12¾ in. (22.6 x 32.4 cm.)

Scripps College, Young
Collection, 1946

Dwight William Tryon's successful bookstore enabled him to open a studio in his home town of Hartford, Connecticut, in 1873. He went to Paris from 1876 to 1879 to study at the École des Beaux Arts, first under de la Cherreuse, pupil of Ingres, then with the Barbizon painters Harpignies and Daubigny, and finally under Guillemet. Tryon returned to New York in 1881, establishing a studio there and a summer studio in South Dartmouth, Massachusetts, two years later. From 1885 until 1923, when he retired, Tryon was professor of art at Smith College.

Tryon is one of the best known popularizers of Tonalism, a late 19th-century American artistic attitude[1] in which "nature [was seen] as a private and extremely personal experience" and was depicted by "evocative half-lights, bathing [scenes] in the light of dusk, dawn or mist."[2] While Tryon's works are reminiscent of his Barbizon training, they are also strongly characterized by an insistence on the "subtle nuances of atmosphere [rather] than [on] the empirical examination of natural light and color"[3] and are more abstract than realistic in effect.

Usually concentrating on rural New England subjects, whether seascape or landscape, Tryon often repeated images and re-worked earlier paintings. During his last decade the artist produced only a few paintings. They are small; some, like *Evening*, are on panel. Yet the basic format of his *oeuvre* remains: a strongly defined mid-horizon line composed of a lateral succession of thin-trunked trees with web-like branches, a tripartite division of the painting, and a lack of depth caused by forms placed close to the picture plane. —*NSG*

[1] William H. Gerdts et al., *Tonalism: An American Experience* (New York: Grand Central Art Galleries, 1982).
[2] Wanda M. Corn, *The Color of Mood: American Tonalism 1880–1910* (San Francisco: M. H. De Young Memorial Museum and the California Legion of Honor, 1972), 1–2.
[3] Bermingham, *American Art In the Barbizon Mood*, 64.

*Charles Courtney
Curran
1861–1942*

SUNSHINE AND HAZE, 1922
oil on canvas
30 x 30¼ in. (76.2 x 76.8 cm.)

Scripps College, Young
Collection, 1946

Born in Kentucky, Charles Courtney Curran was raised in Norwalk, Ohio. After attending the Cincinnati School of Design, he went to New York about 1879 and studied at the National Academy of Design and the Art Students League. From 1889–1891 Curran studied at the Académie Julian in Paris. After 1900 he returned to New York and taught at the Pratt Institute and the Art Students League. He also began to spend his summers at the artists' colony of Cragsmoor, near Ellensville, New York. The site was chosen by the artist Edward Lamson Henry after he visited it around 1879 and subsequently built a house there. A number of artists, including Curran, "were attracted [to Cragsmoor] by the unobstructed views of the surrounding valleys and mountains, the frequently changing lights, and the constantly blowing cool breezes."[1]

At Cragsmoor, as William Gerdts has commented, "Curran could position his figures [who were primarily healthy young women] high up, silhouetted against the brilliant blue sky, isolated from all other concerns in unchanging, sun-drenched summertime."[2]

Sunshine and Haze is typical of Curran's Cragsmoor work. The carefully modeled and highlighted solitary young woman contemplates the sunny, breezy summer day, and the entire composition is idealized by the artist's strikingly vivid palette. —*NSG*

[1] Oswaldo Rodriquez Roque, *Directions in American Paintings 1875–1925: Works from the Collection of Dr. and Mrs. John J. McDonough* (Pittsburgh: Carnegie Institute Museum of Art, 1982), 26.
[2] Gerdts, *American Impressionism*, 97.

Gari Melchers
1860–1932

THE CARESS, 1921
oil on canvas
23 x 18 in. (58.4 x 45.8 cm.)

Scripps College, Young
Collection, 1946

Gari Melchers complied with his father's wish that he study at the Royal Art Academy in Düsseldorf and enrolled there as a student of Gebhardt and Janssen in 1877. He then went to Paris in 1881 and studied at the Académie Julian with Boulanger and Lefebvre and later at the Ecole des Beaux Arts. In 1884 Melchers established a studio and home at Egmondaan-Zee, Holland; over the door he hung a sign stating his artistic credo, *Waar en Klaar* ("True and Clear"). He returned to live in New York in 1915 and then moved the following year to Belmont, a country house in Virginia near Fredericksburg, though he retained his New York studio. Belmont was eventually deeded to the state of Virginia as a permanent museum of Melcher's works.

A highly acclaimed portraitist, Melchers began a series of works on the theme of the mother and child after his marriage in 1903. This theme was one of several genre types that Melchers had been painting in his earlier, Dutch-influenced works, which were characterized by dark tonalities. By the turn of the century his palette had lightened, his colors were more vibrant, and his brushwork became looser and more vigorous, with a thick build-up of surface paint.[1]

The Caress is apparently a more final version of the undated painting on fiberboard, *Mother and Child* (fig. 11).[2] Both portray the same sitters, Julia Payne and her first child, Ivan, who during the early 1920s were frequent models for Melchers. The less finished brushwork, rapid and broken, and the overall highlighting in *Mother and Child* is transformed by a more even handling of brush, color, and light in *The Caress*. Color tonalities and the child's pose and facial expression are also altered. Melchers considered *The Caress* to be one of his finest versions of the mother and child theme.[3] —*NSG*

[1] Janice C. Oresman, *Gari Melchers 1860–1932: American Painter* (New York: Graham Gallery, 1978), 11, 13; *Gari Melchers (1860–1932): Selections from the Mary Washington College Collection* (Fredericksburg, Virginia: Mary Washington College, 1973), 33-6.

[2] *Gari Melchers: His Works in the Belmont Collection* (Fredericksburg, Virginia: Belmont, The Gari Melchers Memorial Gallery, 1984), 166, fig. 90.

[3] Unpublished collection notes of General and Mrs. Young, 1946, Scripps College.

FIG. 11 Gari Melchers, *Mother and Child*, oil on fiberboard, Belmont, the Gari Melchers Memorial Gallery, Fallmouth, Virginia

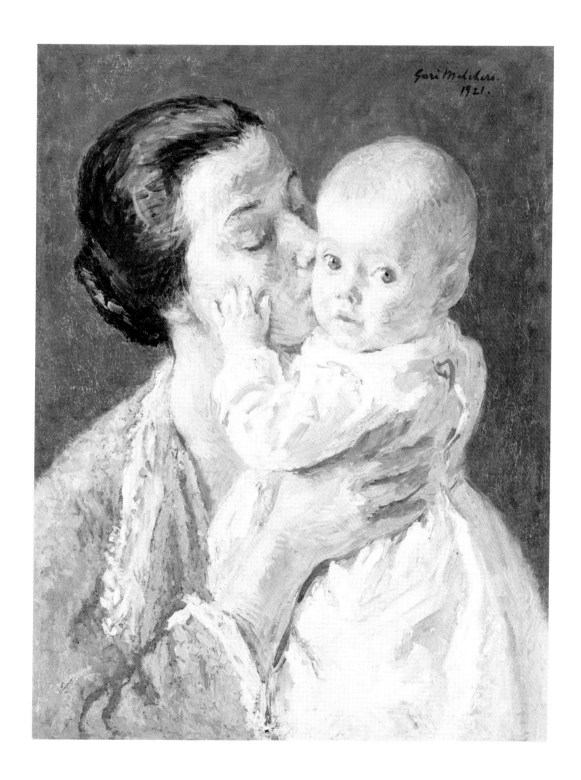

Edward Charles Volkert
1871–1935

SPRING PASTURES, 1922
oil on canvas
20¼ x 24¼ in. (51.4 x 61.7 cm.)

Scripps College, Young
Collection, 1946

Edward Charles Volkert was a second-generation American Impressionist whose style combined Impressionist technique with the Barbizon aesthetic of Millet and the animal painter Constant Troyon. Volkert, born in Cincinnati, studied under Duveneck at the Cincinnati Art Institute; from 1899 he was a student of William Merritt Chase in New York. He began his career as a portraitist and became accomplished in watercolor. He later changed to landscape painting and concentrated on pastoral subjects incorporating farm animals, especially cattle.[1] In 1922, he moved to the farming community of Hamburg, Connecticut, which was adjacent to the art colony at Old Lyme.

Volkert painted directly from nature. *Spring Pastures* is typical of his style, with its clearly-defined sunlight and shade, patchwork colors applied in dots and short brushstrokes, and tangible quality of the cattle. The deep green and yellow of the vegetation, the blue of the shadows, and the brushwork successfully depict dappled sunlight. Even though the picture plane is shallow with a dissolving background, the cattle remain a solid presence because of the artist's effective modeling of color and light.

Even though Volkert's painting utilizes many elements of Impressionism, its subject matter is closer in spirit to Barbizon romanticism:

> It is pure farming land where the plowing and hauling of wood is done by oxen teams, where cattle and sheep are driven down dirt roads that are lined with stone walls, and where they stop to drink at brooks rather than cement culverts. Volkert captured a way of life that was quickly changing as a result of modernization.[2] —*MML*

[1] Catherine A. Leonhard, ed., *An Exhibition of Paintings by Edward Charles Volkert, A.N.A.* (Cincinnati: Mary Leonhard Ran Gallery, 1983), 2.
[2] Ibid.

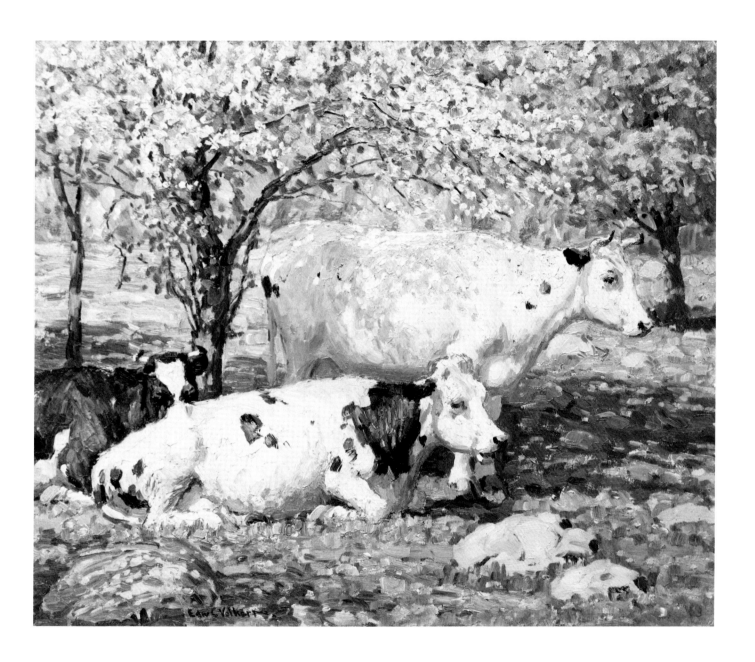

The Ashcan School

Frank Duveneck
1848–1919

THE OLD SEA CAPTAIN, 1879
oil on canvas
24¾ x 20¾ in. (62.8 x 52.6 cm.)

Scripps College, Young
Collection, 1946

Frank Duveneck, born in Covington, Kentucky, began his art career at the age of fourteen, working with a Cincinnati decorative artist painting church murals. He remained a painter of religious art in the Midwest and Quebec until 1870, when he traveled to Munich and entered the Royal Academy of Art. There he was influenced by the Courbet-inspired realist Wilhelm Leibl and developed an affinity for the art of Hals and Velasquez. When Duveneck returned to America three years later he had already developed a mature and vital style. Duveneck's solo exhibition of five portraits at the Boston Art Club in 1875 brought the "Munich Style" to the attention of the American public and great critical acclaim to the artist. Henry James called him an American Velasquez and wrote:

> These are all portraits of men—and of very ugly men; they have little grace, little finish, little elegance... Their great quality is their extreme naturalness, their unmixed, unredeemed reality. They are brutal, hard, indelicate. [1]

Duveneck returned to Munich and opened his own school in 1878. A year later, he moved the school to Florence, and during the next decade, in the company of his cadre of students, "the Duveneck boys," he traveled extensively throughout Europe, returning to America in 1888. Until his death Duveneck was based in Cincinnati, teaching at the Cincinnati Academy of Art and traveling periodically in Europe and America.

During the 1870s, Duveneck's realism consisted primarily of genre portraits. *The Old Sea Captain*, painted in Munich, represents the culmination of this realist style. Characterized by bold, paint-laden brush strokes, minimal use of color, and strong value contrasts, the visage of this skeptical and aloof old man thrusts out from the murky blue depths of the background, disdainful of both the world and the viewer. Typical of this period in Duveneck's art, the subject is a strongly individualized character, similar in selection and presentation to his better-known portraits *Whistling Boy*, 1872, and *The Old Butcher*, 1879, both of which are in the Cincinnati Academy of Art.

Duveneck's genre portraits of the 1870s provided the prototypes and the inspiration for the painters of the so-called Ashcan School in the first decade of the 20th century. —*ADS*

[1] Henry James, "On Some Pictures Lately Exhibited," *Galaxy* (July 1875) reprinted in Henry James, *The Painter's Eye* (Cambridge: Harvard University Press, 1956), 99.

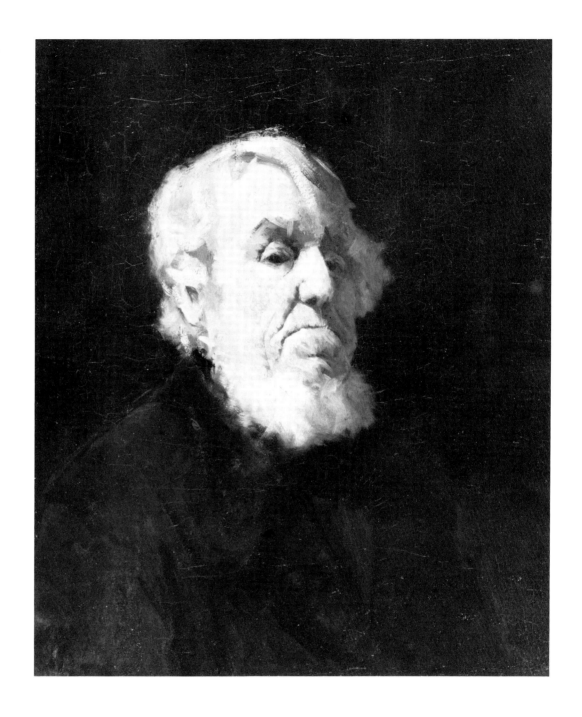

Robert Henri
1865–1929

JIMMY, 1921
oil on canvas
24 x 17⅛ in. (61.0 x 43.5 cm.)

Scripps College, Young
Collection, 1946

Robert Henri, founder of the Eight and leader of the Ashcan School, became the connecting link between 19th- and 20th-century realist art in America. He received his early art training at the Pennsylvania Academy of Art, in which he enrolled in 1886, two years after Thomas Eakins had been dismissed from the directorship for his liberal views on art education. Espousing Eakins' belief that art should combine traditional artistic practices with the depiction of contemporary reality, Henri left Philadelphia after two years and traveled to France to study under the most honored French academician of his day, William Bouguereau, and to absorb at the same time the influences of Manet-inspired realism.

After three years in Paris and Europe, Henri returned to Philadelphia and began giving independent art classes, thus launching a teaching career that brought him more acclaim than did his own artwork. Not only were all the members of the Ashcan School among his students during the following two decades, but he also served as mentor to such artists as Rockwell Kent, Edward Hopper, Patrick Henry Bruce, Man Ray, Stuart Davis, and Alexander Calder.

In 1901 Henri moved to New York, and the city provided the focal point for his subsequent career. Until that time, Henri's art consisted primarily of contemporary landscape and genre. In 1902, however, he began to focus on the human figure with the aim of painting "the greatest portrait in the world in thirty minutes."[1]

Henri assumed leadership of the radical realist artists of New York when he organized the Exhibition of the Eight at the Macbeth Galleries in 1909 as a protest against the rejection of realist art from the annual exhibition of the National Academy of Design. Along with Henri, William Glackens, George Luks, Everett Shinn, and John Sloan exhibited realist works, while Arthur B. Davies, Ernest Lawson, and Maurice Prendergast exhibited their symbolist and Impressionist-inspired works in support of the protest. Henri opened his own art school in New York in 1909, and thereafter devoted most of his activity to teaching and lecturing. He painted during the summers, which he usually spent away from New York City.

Jimmy was painted in Woodstock, New York, during the summer of 1921. The sitter, a country boy named Jimmy Gerry, is typical of Henri's subjects in his later years, when he favored portraits of children, especially young boys.[2] Posed casually in his everyday clothing, isolated against a dark, neutral background, and painted with broad, rapidly applied brush strokes in the earth tones of ochre and umber, the lad reveals to the spectator his friendly and rather blasé country character. —*ADS*

[1] Bennard B. Perlman, *The Immortal Eight* (Westport, Connecticut: North Light Publishers, 1979), 95.
[2] Robert Henri, *Notebooks*, 1921, 97 (Courtesy Janet J. LeClair, Glen Gardiner, New Jersey).

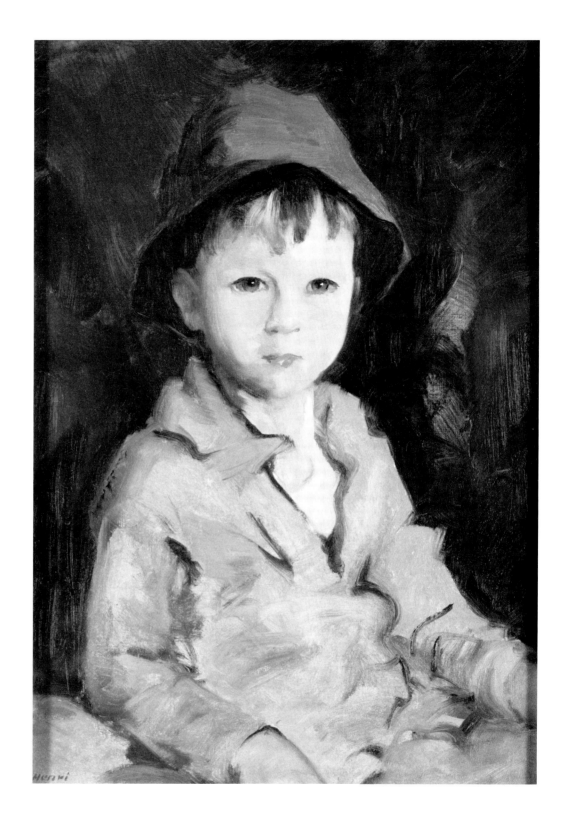

George Luks
1867–1933

BLEECKER STREET KID, C. 1914–28
oil on canvas
15¼ x 12¼ in. (38.8 x 31.0 cm.)

Scripps College, Young
Collection, 1946

Like so many of the Henri circle of American realists who made their artistic reputations in the decade preceding World War I, George Luks, "Chicago Whitey," (or "the terror of the Windy City," as he liked to call himself), came to New York from Philadelphia primarily to forward his career as a newspaper artist. Luks arrived in the Big City in 1896 by way of a slow freighter from Cuba rather than by express train to Philadelphia Station. Sent to Cuba by the *Philadelphia Evening Bulletin* to cover the Civil War, it seems that he preferred the barrooms of Havana to the battlefields of Oriente and was fired. The *New York World*, however, proved receptive, and Luks remained an editorial artist at that paper for several years, gaining renown as the creator of numerous cartoons and editorial illustrations.

It was Luks who convinced his friends William Glackens and Everett Shinn to shift from Philadelphia newspapers to those in New York. In 1898, John Sloan followed, and in 1900 Robert Henri, returning from Paris, accepted a position at the New York School of Art; the nucleus of the famous Eight was established.

Glackens, Luks's fellow newspaper artist, held serious views on art and convinced his colleague to commit himself to painting. Luks did so in a style akin to that of Robert Henri, but characterized by a greater bravura and harshness of execution, in tune with his own florid extroversion. His subjects were life in the streets of the metropolis, the slums, and the tenement canyons. Most often, though, he depicted people (fig. 12), isolated or in groups.

Luks reportedly found the subject of *Bleecker Street Kid* on the street just after his mother had put a bowl on his head and clipped him on Sunday morning. "He was ready for church, but Luks pulled him in and painted him then and there."[1] Somewhat resembling Henri's *Jimmy*, the "Kid," painted in a three-quarter view, looks out of the

painting at the spectator with a rather veiled gaze. His newly bobbed hair, his clean white collar, and his brilliant yellow bow tie vibrate with thick rapid brushwork, surrounding the more calm, Impressionistic facial forms and thrusting the figure out from the neutral umber background. The flat black jacket acts as a base for the vigorously framed head.

The painting appears typical of a later phase of Luks's art. Generally, Luks's single figure paintings before the Great War stressed the figure in motion, even if the subject merely turned or lifted a head, as in *The Sand Artist* of 1905. Luks's earlier works also showed more of the figure and often more background than is visible here. These changing characteristics support the assignment of a post-1914 date to *Bleecker Street Kid.*—ADS

[1] Unpublished collection notes of General and Mrs. E.C. Young, 1946, Scripps College.

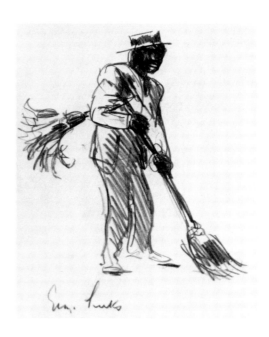

FIG. 12 George Luks, *Street Sweeper*, black crayon on paper, Scripps College, Gift of Gertrude Coffin Shelton, 1975

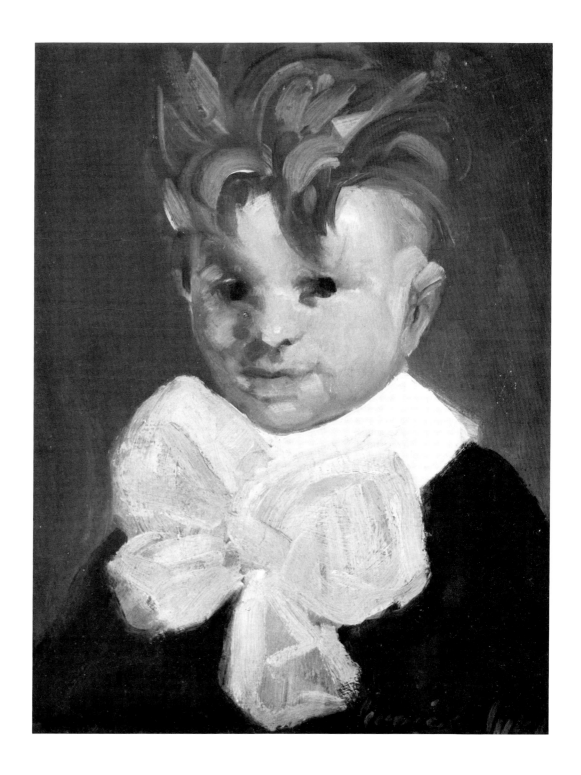

William James Glackens
1870–1938

WOOD LILIES, C. 1920–26
oil on canvas
15½ x 12¼ in. (39.4 x 31.1 cm.)

Scripps College, Young Collection, 1946

Of the Eight, whose revolutionary exhibition of 1908 at the Macbeth Galleries in New York forced the realism of the Ashcan School onto the American cultural scene, only John Sloan achieved a greater artistic reputation than William Glackens. Yet Glackens, almost immediately after having established himself as an avant-garde big city realist, abandoned the style of dark, murky, broadly brushed paintings based on the tradition of Manet and Goya for an art of brilliant color and sinuous paint strokes more akin to the late Impressionism of Renoir. In 1910, having become one of the organizers of the Independents, he exhibited *Nude with Apple*, a painting updating a common academic subject with the bright, warm colors of Impressionism, quite irrelevant to the Ashcan aesthetic of life in the teeming metropolis. This change of artistic focus, which came about partly because of Glackens' friendship with Dr. Albert C. Barnes, the famous collector of European moderns, occurred before Glackens traveled to Europe with Barnes in 1912.

True to the realist credo, however, Glackens continued to create paintings based upon his own direct vision. His outdoor scenes were painted *en plein-air,* and when the weather prevented painting outside, he chose subjects appropriate to the indoors. This accounts for the large number of flower paintings in his later art. Ira Glackens, son of the artist, commenting on the summer Glackens spent in Conway, New Hampshire, in 1920, reports that " [Glackens] produced a few landscapes and some flower pieces and still lifes when the need to paint grew too great and the out-of-doors too green and buggy."[1]

Wood Lilies appears to be a work produced out of this need to paint. Its modest size and simplicity of subject are different from later flower paintings such as *Red and White Anemones,* 1928, or *Zinnias in a Quimper Pitcher,* c. 1930, in which larger scale, a profusion of blossoms, an oblique viewpoint, and a more elegant container produce much more complex images than the one found here. The artist paints this small bouquet frontally as if the flowers were specifically arranged to be placed on the narrow shelf and to be viewed from only one side. Obviously delighted with the beauty of these few blossoms, Glackens uses a bravura technique to make the small painting expand with warmth and pleasure. — *ADS*

[1] Ira Glackens, *William Glackens and the Ashcan Group,* (New York: Crown Publishers, 1957), 194.

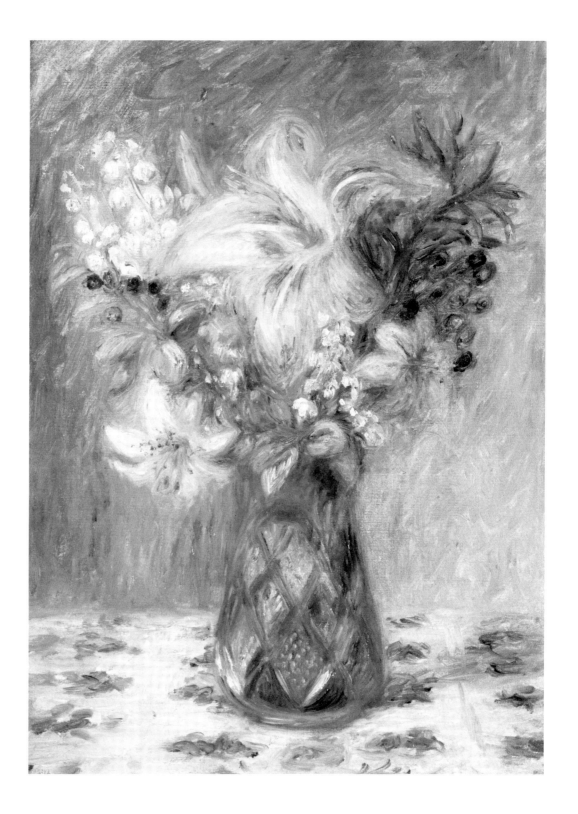

Eugene Higgins
1874–1958

FORDING THE STREAM
oil on cardboard
9¼ x 7¼ in. (23.5 x 18.5 cm.)

Scripps College, Young
Collection, 1946

The art of Eugene Higgins, who was throughout his life an artist of the poor and downtrodden, relates to the Ashcan School. However, his background, his training, and the content of his art differed significantly from the followers of Henri and the Eight. His heritage was working-class Irish and his roots were in the Midwest. He had never been to Philadelphia, but instead took his early training in the art schools of St. Louis.

Like most of his generation of American artists, he traveled to Paris and studied there with Laurens, Constant, and Gérôme at the Académie Julian, which catered to American artists who had failed to gain admission to the École des Beaux Arts. Unlike most of his fellow American expatriates, Higgins achieved some fame in Paris. In 1904, the *Assiette de Beurre*, a famous Parisian left-wing journal, devoted an entire issue to his art. The sixteen pages of pictures, under the title of "Les Pauvres," depicted scenes of human dignity under conditions of deprivation. Also in 1904, after five years in France, Higgins returned to the United States and settled in New York to continue his career as an artist of the poverty-stricken—workers, tramps, peasants, the sad and the hungry. While Henri and his followers stressed portraiture in their Manet-inspired style of realism, Higgins painted symbols and generalized figures based upon Millet and Daumier.

Fording the Stream, while small in size, is typical of his approach. The two figures are almost faceless beneath the heavy encrustation of oil paint, and the scene itself is a generalized group of landscape elements—trees, water, meadow, and sky—combined in an indistinct spatial relationship. Warmth and tenderness emanate from the scene, as the child firmly embraces his protector, and the young man himself resolutely grasps the child's leg.

The weight of the small child causes the husky young man to bend as though he were transporting a truly heavy burden, and in a sense, he is. The Christian theme behind the painting is the legend of St. Christopher, patron saint of travelers, who responded to a child's request to be carried across a stream. With each step, the weight of the child increased until the husky saint was bowed down with his burden. The child then revealed that he was Jesus Christ: Saint Christopher was carrying the weight of the world on his shoulders. Higgins implies that ordinary human beings are capable of carrying that weight with humanity and dignity. In *Fording the Stream*, a simple genre scene is raised to an incident of great symbolic significance through the use of traditional Christian imagery.—*ADS*

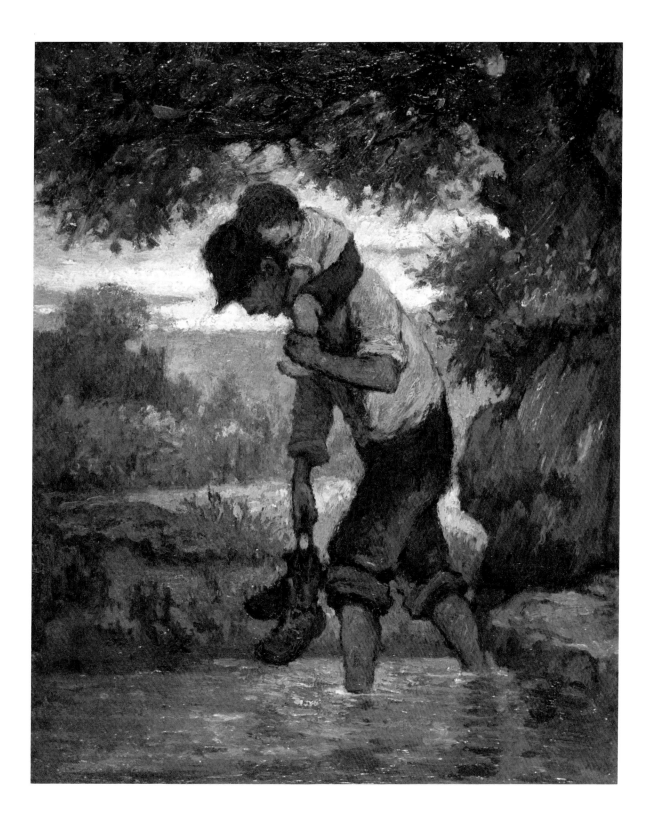

Jerome Myers
1867–1940

EVENING ON THE OLD WHARF,
NEW YORK CITY, 1921
oil on canvas
25⅛ x 30¼ in. (63.8 x 76.8 cm.)

Scripps College, Young
Collection, 1946

Jerome Myers, who painted the crowded slums of New York's Lower East Side, was identified with the radical realist school of New York from the time he began his art career. In 1906 his friendship with John Sloan brought Myers into the Henri group and he became a proud member of the "Black Gang," as the group was derogatorily referred to in those years. While Myers did not exhibit with the Eight at the Macbeth Galleries in 1908—possibly because his own first solo exhibition opened that spring—his works appeared in the first Independents Exhibition in 1910. In a move he later bitterly regretted, he conceived with Walt Kuhn and Elmer MacRae the Association of American Painters and Sculptors, the organization that mounted the Armory Show. Myers persuaded Arthur B. Davies to assume the presidency of the Association, and he later wrote that "Davies had unlocked the door to foreign art and thrown the key away,...more than ever before our country became a colony; more than ever before we had become provincials."[1]

Yet Myers is miscast as a realist. His paintings of slum-dwellers focus on warm, harmonious family and neighborly interactions. Even though Myers springs from the tradition of Daumier, employing the same kind of impasto, color relationships, simplified cityscape backgrounds and stylized figure types, a sweetened Daumier is the result. Dirt, rags, fatigue, grimness, and desperation, the standard ingredients of urban realist art, are lacking in Myers's idealized compositions. His slum-dwellers appear in moments of leisure—the old, middle-aged, and young in tensionless accord; mothers and grandmothers with infants in arms, placidly conversing; well-dressed children playing quietly together—each group portrayed in ample space against a generalized city background devoid of the evils of poverty.

All these qualities are present in *Evening on the Old Wharf*. Myers used this wharf in several paintings. The teeming slums are in the background, appropriately grim in the fiery glow of a smoke-filled sunset. The two carefully composed groups of women and children are distanced from that grimness by the river and the barrier of the wharf's railing behind them. Their figures project a mood of peaceful quietude, gentleness, and humanity. Clearly, Myers views the life of the poor through a veil of romanticism.

Throughout the 1920s Myers's artistic reputation remained high. Perhaps during that decade of rapid industrial expansion and prosperity, romantic views of slum life were possible and acceptable, since poverty was seen as a transitory phase in the struggle toward the realization of the American Dream. The sense of despair and disillusionment brought on by the Depression in the 1930s rendered Myers's vision of the masses obsolete, however, and he gradually faded into artistic obscurity. —*ADS*

[1] Jerome Myers, *Artist in Manhattan* (New York: American Artists Group, 1940), 36–37

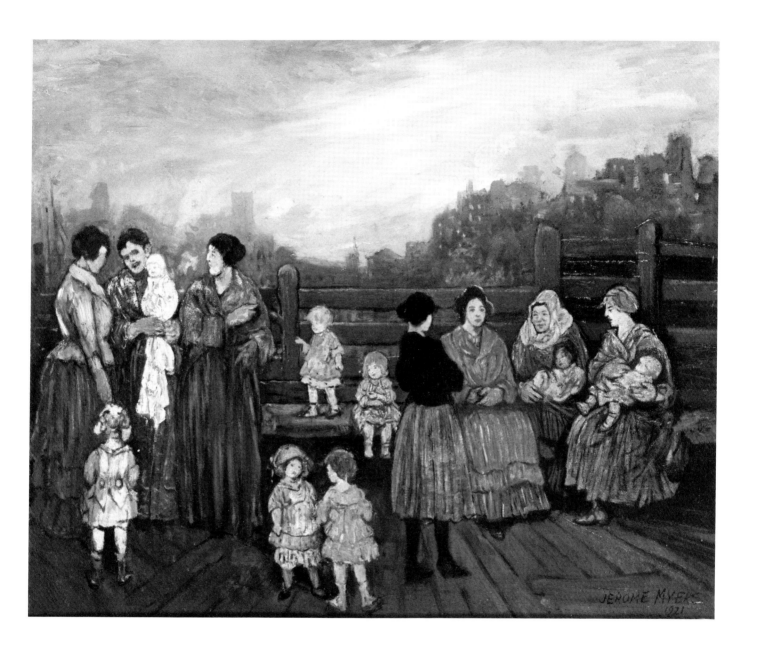

Eugene Speicher
1883–1962

MARY ELIZABETH (or ALICE,), 1927
oil on canvas
21½ x 18³⁄₁₆ in. (54.6 x 46.2 cm.)

Scripps College, Young
Collection, 1946

Eugene Speicher's association with the Ashcan School began during his art student days when, after four years of study at the Albright Art School in Buffalo and two at the Art Students League in New York City, he moved in 1907 to the Henri School of Art. Along with fellow students George Bellows, Edward Hopper, and Rockwell Kent, he studied under Robert Henri. Like most of his contemporaries, Speicher spent some time in Europe but he received no formal art instruction there. He taught at the Art Students League from 1908–13, and again in 1919–20. Between the wars, Speicher received numerous awards, medals, and honors for his painting. In 1945 he became director of the American Academy of Arts and Letters.

Mary Elizabeth, originally entitled *Alice*, had its title changed by the collector to his wife's name because he felt the portrait resembled her as a child. The sitter was the daughter of a friend of the Speicher family and a resident of Woodstock, New York, the artists' colony where Speicher spent his summers. Alice Reynolds was twelve in the summer of 1927 when she sat for the portrait. The artist selected the peasant blouse and the scarf she wears and combed her hair back from face and forehead, thereby transforming this young, contemporary American girl into a universal and classical image of the seriousness, beauty, and dignity of female childhood on the brink of maturity.[1]

> Speicher's credo states his intention:
> My look and feel of the thing I am
> painting: my imagining and thinking
> about it, is what I try to express, be it a
> portrait, a figure, a landscape or a bou-
> quet of flowers. Something that is not
> merely original and short lived but
> which is supported by fundamental
> principles as well.[2]

He paints the features of his sitter in smooth, fused brush strokes and, in the Velasquez-Goya-Manet-Henri tradition of portraiture, reserves the vitalizing bravura for the facial framing devices of hair, costume and background. Earth tones dominate the palette, enlivened by the maroon scarf knotted loosely around the model's neck and the warm glow emanating from her face. The mood of serious contemplation reflected in her facial expression is emphasized by the light, which falls most brightly on her forehead, symbolically revealing the intensity of the child's thoughts. — *ADS*

[1] Personal letter from Alice M. Reynolds to Arthur D. Stevens, September 3, 1983.
[2] Eugene Speicher, *Eugene Speicher* (New York: American Artists Group, 1945), 2.

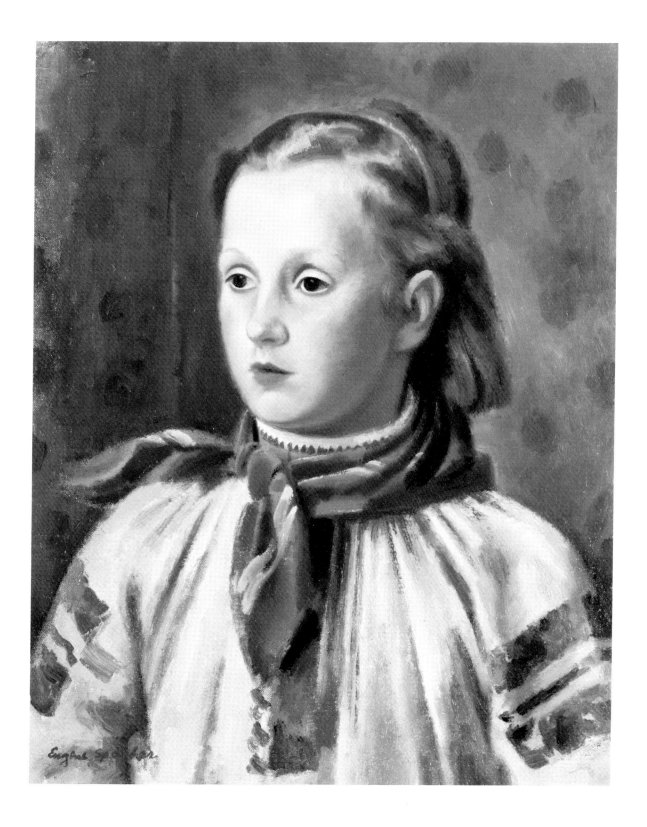

Ernest Lawson
1873–1939

SPRING
oil on canvas
20 x 24 in. (50.8 x 60.9 cm.)

Scripps College, Young
Collection, 1946

rnest Lawson was an unusual associate of the famous Eight in that neither his early training nor his approach to painting resembled those of the Ashcan School. His membership in the group came about because of the proximity of his New York studio to that of William Glackens, who introduced him into evening gatherings at the Cafe Mouquin and the Cafe Francis. Lawson, born in Halifax, Nova Scotia, received his major art training at the Art Students League under the tutelege of Twachtman and Weir. He also studied at the Académie Julian in Paris and was directly influenced by the Impressionist Alfred Sisley.

By the time he met Glackens, Lawson had already been identified as "America's greatest landscape painter" by the famous William Merritt Chase.[1] Lawson's landscapes often depicted the contemporary encroachment of the expanding city onto the surrounding rural countryside, with dark and dirty tones invading the more serene and pure hues of the Impressionist palette. Unlike his friends of the Ashcan group, Lawson painted no crowded streets nor teeming tenements. His daughter reported that he was not interested in the ugliness of too much realism because it did not concern him and his style of painting.[2]

Spring represents one of the artist's continuing themes. Lawson's fascination with the change of seasons and the resulting effects these shifts had on the landscape is demonstrated in a large number of his works and by the expressive energy in these paintings. *Spring* shimmers with a thick encrustation of oil paint, built up in uneven layers and finished with thin, flickering strokes to define the foreground trees and foliage. In this area of the canvas, the paint is applied with a nervous intensity usually identified with subjects of dark emotional content, yet *Spring*

remains a rather pastoral representation. The gentle horizontal bands of foreground meadow, middle-ground river, background hills, and sky are almost equal in size and shape. The fragile greens of the springtime hills combine with the cool blues of river and sky to create a mood of serenity and quietude that dominates the brash energetic profusion of foreground growth.

The painting, while not unique in Lawson's *oeuvre*, is atypical. No boats appear on the river, nor sheds on the hills. Nature here is untouched by humanity, and the foreground harshness of form expresses the restless compulsion of nature itself for growth and life. — *ADS*

[1] Perlman, *The Immortal Eight*, 102.
[2] Henry and Sydney Berry-Hill, *Ernest Lawson, American Impressionist* (Leigh-on-Sea: F. Lewis Publishers, 1968), 27.

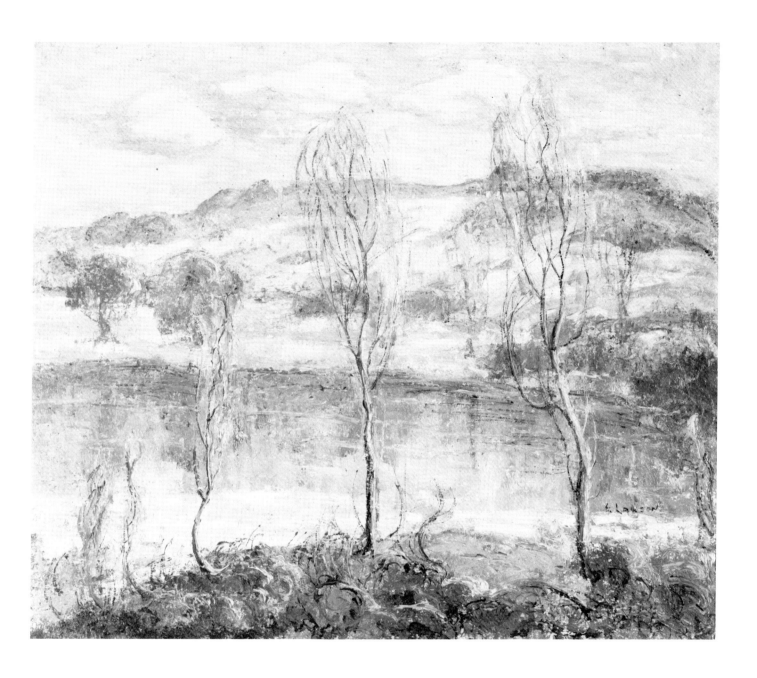

Rockwell Kent
1882–1971

NEWFOUNDLAND HARBOR,
c. 1914-15
oil on canvas
34⅛ x 44¹/₁₆ in. (86.4 x 111.9 cm.)

Scripps College, Gift of Merle
Armitage, 1946

Rockwell Kent possessed all of the credentials of an Ashcan School painter by 1906, when he completed his formal art education under William Merritt Chase and Robert Henri. Kent's fascination, however, lay with raw nature rather than crowded city streets, and he sought his subjects along the rugged coastlines of Maine and Monhegan Island, working more in the tradition of Winslow Homer's realism than in that of the Ashcan group.

There had been a Maine school of landscape artists for some time. Kent, it seems, sought subjects not previously recorded, but still containing the drama and grandeur found in the confrontation of sea and rugged coastline. Apparently, though, even the harshness of the Maine climate and terrain lacked the untrammeled ruggedness he desired. In October of 1910 he visited Newfoundland and in its wild magnificence discovered his natural paradise.

In March of 1914, Kent moved his family to the Newfoundland port of Brigus on Conception Bay, forty miles by rail from St. Johns. Five months later World War I broke out, and provincial British jingoism became rampant. Kent did not share the hysteria, and his new neighbors became very cool to him. As Kent later commented,

> The war, the senseless sacrifice of lives, the hatred war engendered; and, on us, the foul suspicions so at variance with our true, innate integrity; these facts oppressed me to a degree to which I only let my work give utterance. *Ruin and Eternity, The Voyager Beyond Life, Newfoundland Dirge, Man and the Abyss, The House of Dread:* such were my titles when I later showed the work. [1]

Newfoundland Harbor seems to have been painted shortly after his arrival in Brigus, well before the depressing mood of suspicion set in. The season is summertime, with a clear sky and a calm ocean. The bare, treeless rocks in shades of beige and umber shelter small areas of verdant vegetation and the white houses of the villagers. The sea is dark and deep, as is usual in Kent's wilderness paintings, and the contrast of mood between sea and land expresses a moment of serenity in the struggle between nature's forces and human survival.

In July of 1915, Kent and his family were deported as undesirable aliens, thus giving credence to the gloomy prophecy of his later Newfoundland art. He would continue to search the wilderness for subjects, however, because for him, therein lay reality:

> In my own painting, and in what from time to time in these pages I may say about art, I will appear to be an exponent of realism—though not, I trust, to the exclusion of other schools of expression. Basic to realism is the concept that our universe in all it comprehends is, as the primeval and eternally persistent conditioner of man, the norm to which his senses are attuned—so perfectly that he denotes it beautiful. It is to the recognition and display of that inherent beauty that realism is devoted. Its hallmark is its truth. [2]

In seeking the sources of this realism, Kent was to live in Alaska (fig. 13) and Greenland, and to paint the Straits of Magellan before he turned to tamer subjects with the onset of old age. —*ADS*

[1] Rockwell, *It's Me, O Lord* (New York: Dodd, Mead and Company, 1955), 289.
[2] Ibid., 211.

FIG. 13 Rockwell Kent, *Chart of Northwest Harbor, Resurrection Bay, Alaska,* 1919, pen and ink on paper, Scripps College, Gift of Merle Armitage, 1946

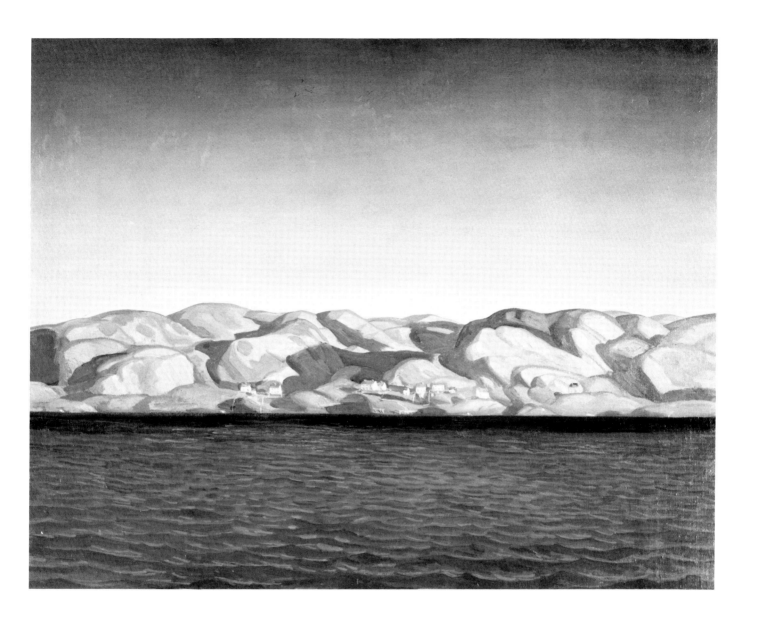

New England Painters

Paul Dougherty
1877–1947

MAINE COAST
oil on canvas
18 x 24¼ in. (45.8 x 61.5 cm.)

Scripps College, Young
Collection, 1946

Paul Dougherty, once heralded as the successor to Winslow Homer in marine painting, was born in Brooklyn, New York, to a family of established wealth. He traveled and studied art extensively in Europe, exhibiting at the Paris Salon in 1901. In 1907 he was elected to the National Academy of Design. He won many other awards during his career, including a gold medal at the 1915 Panama Pacific Exposition in San Francisco. His many trips to Asia and the Caribbean inspired his prolific work in watercolor. From 1932 until his death Dougherty lived primarily in Carmel, California.

Although Dougherty painted a variety of locations at home and abroad, his seascapes of the Maine coast are his most famous works. *Maine Coast* is typical of his marines, with its foreground rocks, rough sea, and high horizon line. As in the late works of Homer, all human presence—figures, dwellings, vessels—has been eliminated. The only subject is the dramatic and stark interaction between the sea and the rocks. Broad brushstrokes of blue, brown, ochre, and orange define the structure and surface of the shore. A debt to Cézanne is apparent and this distinguishes Dougherty's style from the greater realism of Homer.

Dougherty's marines, especially his more abstract and transparent works in watercolor, can be compared with those of John Marin, who also worked in Maine from the mid-1910s. However, while Marin absorbed both Cubism and Futurism, Dougherty remained firmly within the tradition of American realism. —ML

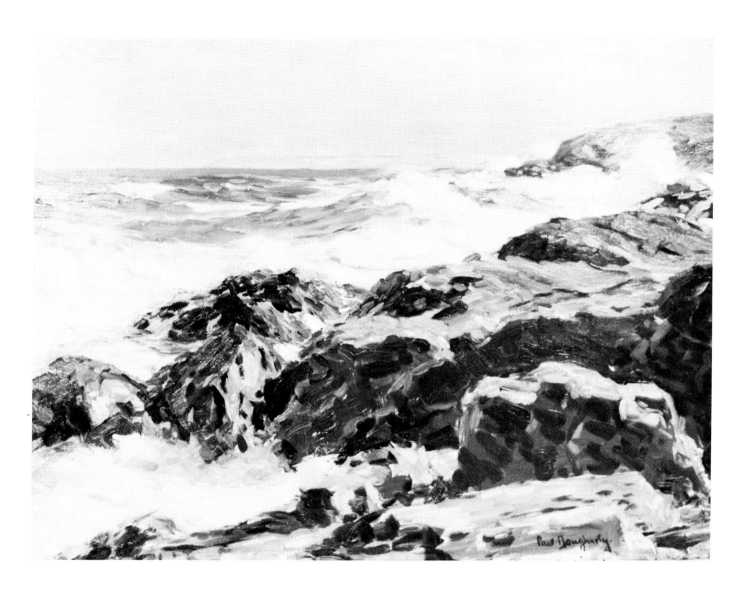

Max Bohm
1868–1923

IN THE GLOAMING, 1922
oil on canvas
32 x 26¼ in. (18.3 x 66.7 cm.)

Scripps College, Young
Collection, 1946

At the age of eleven, Max Bohm entered the Cleveland Art School in his hometown. In 1887 his aunt, Anna Weitz, an artist, invited Bohm to come and stay with her in Paris. While there Bohm studied at the Académie Julian and with Laurens, Lefebvre, and Constant at the École des Beaux Arts. He subsequently lectured on the theory and practice of pictorial composition and was an instructor in painting in Paris and London for twelve years. By 1917 Bohm had joined the art colony at Provincetown, Massachusetts. He became actively involved with John Noble and other artists in organizing the Provincetown Art Association in 1921.

Bohm's early works were seascapes, sometimes of ships or boats peopled with sailors or fishermen. Later he began to paint women and children; today he is primarily known as a figure and portrait painter as well as a muralist.

In the Gloaming, painted one year before Bohm's death, is typical of his Provincetown paintings. With its large oblique areas of color, the figures become secondary to a highly abstract composition. For Bohm, the "subjects that elicited his boldest most inspired brush were fashionable women. . ., wind-blown and dramatically lighted."[1] — *NSG*

[1] Dorothy Gees Seckler, *Provincetown Painters 1890s–1970s* (Syracuse, New York: Everson Museum, 1977), 29.

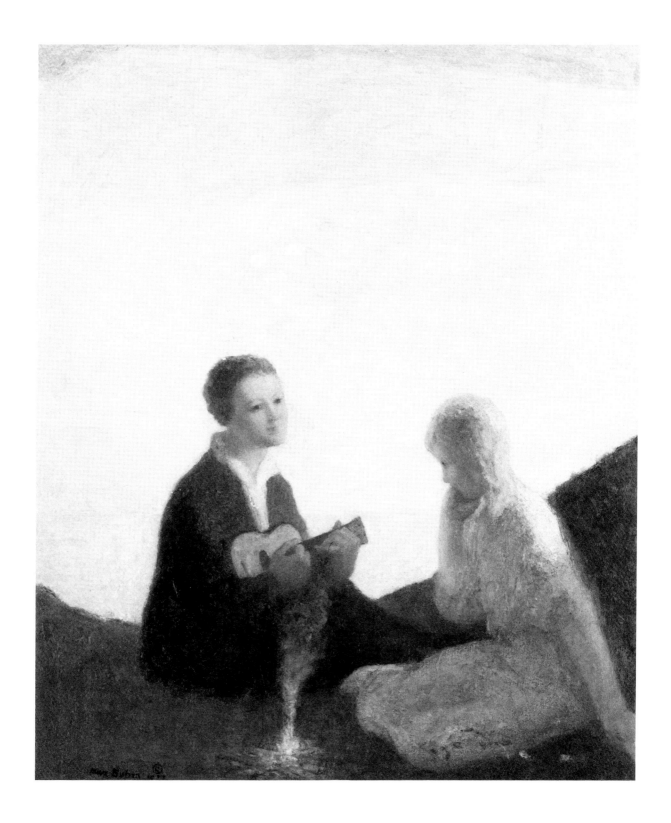

John Noble
1874–1934

FROG POND, C. 1910–20
oil on canvas
12⅛ x 16⅛ in. (30.9 x 40.9 cm.)

Scripps College, Young
Collection, 1946

eturning to his hometown of Wichita, Kansas, from Cincinnati around 1898, John Noble became a partner with a photographer and produced pastels copied from photographic and chromolithographic images. One of these, *Cleopatra at the Bath,* hung at the Carey House Bar and was attacked by Carrie Nation on December 27, 1900. Armed with the sobriquet "Wichita Bill," Noble left in 1903 for Paris, where he became involved in the American expatriate community and studied art briefly with Laurens. He spent summers from 1905 in Brittany and Picardy. Noble moved to England at the beginning of the war and in 1919 left Europe for the artists' colony in Provincetown, Massachusetts. There he became an officer of the Provincetown Art Association. He moved permanently to New York in 1922 but continued to summer in Provincetown.

Though Noble's style underwent dramatic changes as he became interested in various art movements, three basic themes were established when he was working in Brittany — the village, the sea, and working horses.[1]

Frog Pond, painted probably in the 1910s, demonstrates an intermixture of styles with its Fauve-like background of large blocks of color; its sinuous curvilinear trees inspired by Art Nouveau; and in the manner of Monet, its blending of an image with its reflection in water.

Baiting the Line (fig. 14) depicts one of Noble's major themes — the sea. This piece was certainly painted during the mid-20s.[2] Its subject and style reflect the Provincetown colony's artistic credo of the realistic depiction of American scenes.[3] Yet, as Howard DaLee Spencer has pointed out, Noble's works at this time also have "a rather phantasmagorical quality [and his images] were often compared to Ryder."[4] — *NSG*

[1] Howard DeLee Spencer, *The Legendary Wichita Bill: A Retrospective Exhibition of Paintings by John Noble* (Wichita, Kansas: Wichita Art Museum, 1982), 20.
[2] Cf. *The Sardine Fisherman,* datable to c. 1922–1924, Ibid., pl. 5.
[3] Seckler, *Provincetown Painters,* 14.
[4] Spencer, *Wichita Bill,* 31.

FIG. 14 John Noble, *Baiting the Line,* oil on canvas, Scripps College, Young Collection

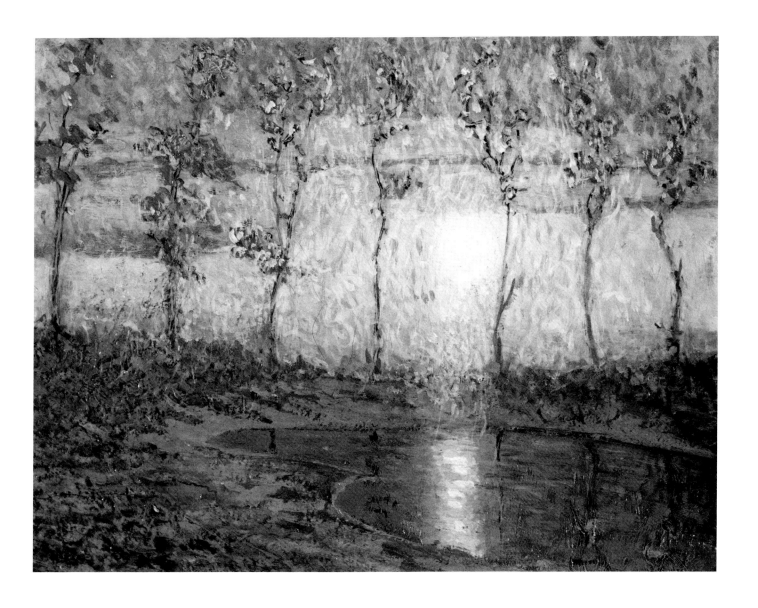

Charles H. Davis
1856–1933

RED BARN
oil on canvas
13 x 16 in. (33.0 x 40.6 cm.)

Scripps College, Young
Collection, 1946

Charles H. Davis first studied at the School of the Museum of Fine Arts, Boston. A businessman from his hometown of Amesbury, Massachusetts, later financed Davis' study under Lefebvre and Boulanger at the Académie Julian in Paris. Davis remained in France for ten years, traveling frequently to Barbizon and the Fontainebleau region. His early paintings, indebted to the Barbizon School, emphasize somber tonalities and simple, solidly drawn compositions. George Inness is said to have admired Davis' work of the early 1890s.[1]

Davis next settled in Mystic, Connecticut, and was central in the town's development as an art colony. Throughout his life the rural environment was his source of subject matter, as it had been for John Constable and the Barbizon painters, the dominant influences in his work.

Davis is best known for his summer landscapes of green farmsteads under cumulus clouds in blue skies. *Red Barn* portrays the verdant Connecticut countryside with its stone walls and red farm buildings. After 1895 Davis experimented with Impressionist technique and brighter colors; this experimentation is evident in *Red Barn*. Other indications of late 19th-century painting include the flattened pictorial space and independent brush strokes. However, Davis remained close to the Barbizon sensibility of capturing the poetic moods rather than the perceptual realities of nature. His contrasting colors are subdued—in the style of the Barbizon artist Daubigny—and the picturesque patterns of the trees serve to unify the composition.

An academic painter, Davis sketched from nature and produced the finished painting in his studio. His work was collected by major American museums during his lifetime. —*ML*

[1] Bermingham, *American Art in the Barbizon Mood*, 133.

The 1930s

Guy Wiggins
1883–1962

WASHINGTON SQUARE, WINTER,
1936
oil on canvas
20⅛ x 16⅛ in. (51.1 x 40.9 cm.)

Scripps College, Young
Collection, 1946

Even though Guy Wiggins worked in many styles during his career, his American Impressionist paintings were the most popular. Wiggins studied with his father, Carleton Wiggins, a well-known landscape and livestock painter; William Merritt Chase; and Robert Henri. With no European training, Wiggins learned the Impressionist vocabulary through his awareness of the paintings of Hassam and of Twachtman, who was noted for his snow scenes. At the age of twenty Wiggins was the youngest artist to have a work accepted for the collection of the Metropolitan Museum of Art. His most celebrated subject was his native New York City in the snow, interpreted with the urban emphasis of the Ashcan School and the pleasant idealism of American Impressionism.

Washington Square, Winter, painted in 1936, is an excellent example of Wiggins's New York snowscapes. From an elevated viewpoint, snow-covered cars and people are seen slowly making their way across the square toward the archway and buildings beyond. To paint scenes like *Washington Square, Winter,* Wiggins would set up a temporary studio in a building with a window view appropriate to the subject.[1]

The artist achieved the effect of densely falling snow by washing the entire canvas with white and then adding details with Impressionist flecks of paint. This ephemeral quality is balanced by the solid structural forms of the architecture, whose broad planes recall the geometric style of Cézanne. Wiggins's view of New York presents a domesticated image of a city for which he had great familiarity and obvious affection. Washington Square is a famous New York landmark that has been depicted by many artists, including Edward Hopper.

Wiggins was a populist who, though not a Social Realist, promoted art education by speaking to men's organizations on national lecture tours. During the Depression he espoused a policy of setting reasonable prices for paintings. — *ML*

[1] Adrienne L. Walt, "Guy Wiggins: American Impressionist," *American Art Review* 4, no. 3 (Dec. 1977); 104.

John Steuart Curry
1897–1946

TREE STRUCK BY LIGHTNING, 1931
oil on canvas
30 x 24 in. (76.2 x 61.0 cm.)

Scripps College, Gift of Professor
Philip H. Gray, 1971

John Steuart Curry was born and raised in rural Kansas, the region that provided much of the subject matter for his paintings of the 1930s. Curry worked as a magazine illustrator on the East Coast from 1919–26 before studying in Paris in 1927. By the mid-1930s he was one of the leading American Regionalist artists, along with Grant Wood and Thomas Hart Benton. Curry felt that "a sincere and lasting value was to be found in the experienced realities of the basic farm existence,"[1] and he focused his art on rendering the immediacy of those experiences.

Like Wood and Benton, Curry painted murals; his most famous is in the Kansas State Capitol at Topeka. Several of his murals were sponsored by the federal Public Works of Art Project during the 1930s; this sponsorship strengthened the Regionalists' commitment to portraying specific locales in the United States.

Even as a child Curry made drawings of the awesome storms of the Midwestern plains. In many of his mature works he depicted particular moments of storms, ranging from their development through their aftermath, and their effects on people, animals, and nature. *Tree Struck by Lightning* is an early dramatic example of this theme. The immediacy of the storm's effect is emphasized by the jagged break in the fallen bough with its foliage still fresh. A rainbow in the sky indicates the coming of fair weather with its promise of peace and harmony.

There is an anthropomorphic quality to the tree that recalls the art of another Midwesterner, Charles Burchfield. The fleshy color of the "wounded" trunk particularly suggests an analogy between plant and human life in their vulnerable resiliency.

Despite its small size, *Tree Struck by Lightning* has monumentality because of the dominant foreground position of a single motif. Curry used this compositional mode later in several of his most powerful paintings, including *John Brown* of 1939, the subject of which is shown in front of another kind of storm, the tornado. — *ML*

[1] Joseph S. Czestochowski, *John Steuart Curry and Grant Wood: A Portrait of Rural America* (Columbia: University of Missouri Press, 1981), 14.

Henry Lee McFee
1886–1953

SILVER STACKS, C. 1938
oil on canvas
24 x 30 in. (61.0 x 76.2 cm.)

Scripps College, Gift of
Mrs. Eleanor McFee, 1975

Henry Lee McFee gained national recognition as a still life painter. Born in St. Louis, he first studied art at Washington University. In 1908 he entered the Art Students League summer classes in Woodstock, New York, which became his home for many years. Although he never went to Europe, McFee had access to European modernism through his close association with Andrew Dasberg, who worked with the Synchromist painter Morgan Russell in Paris. Together McFee and Dasberg explored modernist styles based on their understanding of Cézanne and Cubism, and with Konrad Cramer they founded the Woodstock art colony.

By the mid-1930s McFee had achieved his own distinctive synthesis of these sources and the formalist theories of Roger Fry and Clive Bell.[1] He wrote that "the canvas will be, when completed, not a representation of many objects interesting in themselves, but a plastic unit expressive of the form life of the collection of objects."[2]

Although still life was his major subject, McFee also painted landscapes such as *Silver Stacks*. Perhaps reflecting the artist's interest in Precisionist industrial and architectural forms, four large smoke stacks tower above the surrounding buildings and trees. In their realistic modeling, they contrast with the subtle Cézanne-like modulations of scale, color, and tone consistently found throughout the rest of the composition. Their dominant presence may indicate McFee's attempt to participate in the widespread realism within American art of the 1930s. In *Silver Stacks*, as in the majority of his paintings, McFee creates an underlying horizontal and vertical structure complemented by diagonal planes and brushstrokes.

In 1942, McFee moved to California, where he taught at Scripps College and the Claremont Graduate School until his death in 1953. —ML

[1] John Baker, "Henry Lee McFee: Realism in the Service of Modernism," unpublished paper delivered at the College Art Association Meeting, Toronto, January 1984.
[2] Arthur Millier, "McFee," in *Henry Lee McFee* (Claremont: The Fine Arts Foundation of Scripps College, 1950), unpaginated.

Index

Anonymous, 19th
 century *14, 16, 18*

Beal, Gifford *94*
Blakelock, Ralph *26*
Bohm, Max *130*

Carlsen, Soren Emil *86*
Cassatt, Mary Stevenson *50*
Crane, (Robert) Bruce *96*
Cropsey, Jasper Francis *20*
Curran, Charles
 Courtney *100*
Curry, John Steuart *140*

Daingerfield, Elliott *46*
Davis, Charles H. *134*
Dougherty, Paul *128*
Duveneck, Frank *108*

Enneking, John Joseph *6, 78*

Fuller, George *44*

Garber, Daniel *7, 92*
Glackens, William James *114*

Haseltine, Charles Field *84*
Hassam, Frederick
 Childe *56, 58, 60*
Henri, Robert *110*
Higgins, Eugene *116*
Howard, M. *32*

Inness, George *22, 24*

Keith, William *28*
Kent, Rockwell *124*

La Farge, John *38*
Lawson, Ernest *122*
Luks, George *112*

Martin, Homer Dodge *40*
McFee, Henry Lee *142*
Melchers, Gari *102*
Metcalf, Willard Le Roy
 70, 72
Moran, Thomas *30*
Murphy, John Francis *82*
Myers, Jerome *118*

Newman, Robert Loftin *42*
Noble, John *132*

Prendergast, Maurice
 Brazil *2, 64, 66*

Robinson, Theodore *52*

Schofield, Walter Elmer *88*
Speicher, Eugene *120*
Symons, (George)
 Gardner *90*

Tarbell, Edmund Charles *62*
Thayer, Abbott
 Handerson *10, 76*
Tryon, Dwight William *98*
Twachtman, John Henry *54*

Weir, Julian Alden *68*
Wiggins, Guy *138*
Wyant, Alexander
 Helwig *80*

Vedder, Elihu *34, 36*
Volkert, Edward Charles *104*

*Galleries of the
Claremont Colleges*